WHEN HULL FREEZES OVER

D0861731

WHEN HULL FREEZES OVER

Historic Winter Tales
from the Massachusetts Shore

JOHN GALLUZZO

THE
History
PRESS

Published by The History Press
Charleston, SC 29403
www.historypress.net

Copyright © 2005 by John Galluzzo
All rights reserved

Front Cover: During the summer months, the boardwalk of the Hotel Nantasket
and the porches of the neighboring establishments allowed thousands of people
magnificent views of the Atlantic Ocean. In winter, when Mother Nature showed
her surly side, those boardwalks and porches could be lonely places.
Back Cover: Assistant Keeper Maurice Babcock poses outside Boston Lighthouse.
Courtesy of Doug Bingham and the American Lighthouse Foundation.

All photos courtesy of the Hull Historical Society except where otherwise noted.

First published 2005; Second printing 2015

Manufactured in the United States

978.1.59629.099.0

Library of Congress Cataloging-in-Publication Data

Galluzzo, John.
When Hull freezes over : historic winter tales from Hull, Massachusetts /
John Galluzzo.
p. cm.
ISBN 1-59629-099-4 (alk. paper)
1. Winter--Massachusetts--History--Anecdotes. 2. Hull
(Mass.)--History--Anecdotes. 3. Hull (Mass.)--Biography--Anecdotes. I.
Title.
F74.H89G35 2005
974.4'82--dc22
 2005023982

Notice: The information in this book is true and complete to the best of our
knowledge. It is offered without guarantee on the part of the author or The History
Press. The author and The History Press disclaim all liability in connection with the
use of this book.

All rights reserved. No part of this book may be reproduced or transmitted in any
form whatsoever without prior written permission from the publisher except in the
case of brief quotations embodied in critical articles and reviews.

Dedicated to Matthew, my godson. Stay warm, little guy.

Contents

Acknowledgements

It's really hard to believe this book has been nine years in the making, but it's true. I started writing for the *Hull Times* in 1997, compiling research I had started gathering at the Hull Lifesaving Museum in 1996. This book consists mostly of material written for that paper and friends Susan Ovans and Roger Jackson, to whom I owe a great deal of gratitude.

Without wanting to slight anybody, I'd like to thank the following people in no particular order for their help over the years: Richard Cleverly, keeper of Hull history for most of his adult life; Chris Haraden, a fellow 1988 Hull High School graduate who's also into the history thing; the directors and officers of the Fort Revere Park and Preservation Society, including Regina Burke, Rick Shaner, Janet Jordan, Graeme Marsden, Fred Hills, Peter Seitz, Sarah O'Loughlin, Susan Oberg and Harvey Jacobvitz; Matt Tobin, the Department of Conservation and Recreation's rock-steady site supervisor at Fort Revere Park; Dan Johnson and the staff of the Hull Public Library, especially Ann Bradford; David Ball and the volunteers of the Scituate Historical Society; my friends in the Coast Guard–history community around the country, including Maurice Gibbs in Nantucket, Ralph Shanks in Novato, California, Fred Stonehouse in Marquette, Michigan, Dennis Noble in Sequim, Washington, Robert Browning and Scott Price at the Coast Guard Historian's Office in Washington, D.C., and all of those who read, contribute to and enjoy *Wreck & Rescue Journal*, of which I'm currently the editor; Town Clerk Janet Bennett; Don Ritz and the Hull Historic District Commission; Al Almeida, with whom I spent many an enjoyable summer's afternoon shooting the breeze while at work at the Hull Lifesaving Museum; Doug Bingham of the American Lighthouse Foundation; Al Vautrinot and the Vautrinot family; the family of "Papa"

Louis Anastos, a man I'll never forget; Town Counsel Jim Lampke and former town manager Phil Lemnios; the staff of the Hull Lifesaving Museum; our own Flying Santa, George Morgan; Sue Fleck, for her family's perspective on the old days in Hull; the family of Doc Bergan; the members of the Committee for the Preservation of Hull's History, most of whom are named above, but others of whom include Myron Klayman, of Paragon Park fame, Brison Shipley and Midge Lawlor; the staff of the Mass Audubon South Shore Sanctuaries, David Clapp, Ellyn Einhorn, Dianne Laxton, David Ludlow and Sharon Seeg; Mass Audubon's Wayne Petersen; Salem author Robert Ellis Cahill; Frannie Keyes; and all those historians, living and gone, who have done their part to preserve the history of Hull. Thanks to everybody who's ever commented on a story, given an idea for a new one or joined me on a walk through Hull history.

Special thanks are reserved for the members of the Coast Guard who serve at Station Point Allerton or have served there over the years, including Chief Warrant Officer Craig Bitler, Senior Chief Boatswain's Mate Bruce Bradley, Chief Warrant Officer Patrick Higgins, Chief Boatswain's Mate Rick Barone, Chief Warrant Officer Paul Sordillo and Chief Boatswain's Mate Jim Bodenrader. While the rest of us bundle up when Hull freezes over, you're standing guard, ready to save the lives of strangers. Thank you for all you do.

My family has never wavered in supporting my dream of researching history, so to my father, Bob, mother, Marylou, sister, Julie, and brother, Nick, thank you.

Two special educators, R. Dean Ware and the late Franklin Wickwire, pointed me down the right path while I studied history at the University of Massachusetts at Amherst, and a special group of friends that go all the way back to that time, David and Kathy Dean, Jay and Leah Kennan, Rich and Felice Eby and Fred Hoth, still make me smile to this day.

My fiancée, Michelle Degni, has given me the space I've needed to make this project come together, and for that, I am eternally grateful. It won't be long now, sweetie.

Any errors fall squarely on my shoulders. Blame me, not them.

Introduction

It sure must have been something to watch the Portland Gale bully its way across town in 1898. And it must have been quite a scene when the old lifesavers of the Point Allerton U.S. Lifesaving Station went into action. And it definitely would have been interesting to stand at Fort Revere with one's back to Hull Gut and watch as the tide washed over Stony Beach during a storm, reminding us all why the local Wampanoag tribe called this place Nantasket, or "the place between the tides."

But then, if you've lived in Hull for the past three years, you've seen literally hundreds of inches of snow hit the ground. You've witnessed the freezing of Hingham Bay and watched as the Coast Guard has brought in icebreakers to clear their way out of their boathouse at Station Point Allerton, which, by the way, is nowhere near Point Allerton. And if you lived here in February 1978, you lived through your own Portland Gale.

The Hull we all know best is the one that exists before Memorial Day and after Labor Day. For most of the year we have the peninsula to ourselves. Hull's summer population has been ebbing and flowing with the seasons since the mid-1800s, rushing to the shore in summer and retreating inland in the fall and winter. As you'll see, they don't know what they've been missing.

Every community has its share of winter tales to tell, but no other single community has the perspective on winter that Hull does. Situated at the mouth of one of the busiest American trading ports and jutting out five miles into the water, the Hull peninsula was for a long time a shipwreck magnet. Northeast winds blew ships to the southwest as they entered Lighthouse Channel, and Hull was there to catch them. Our lifesavers became famous for many reasons, not the least of which were their bravery and ingenuity, yet they also had more opportunities to save lives than the volunteers and government-paid lifesavers of most other towns.

When Hull Freezes Over

It must have been inspiring, too, to look down the length of the peninsula from Allerton Hill and see a scattering of houses here and there, gazing across the famed "plains" of Nantasket Beach. The heart of the community for its first three centuries rested in Hull Village, a site chosen because its hills protected the community from the northeast winds and for the natural spring at the base of those hills. Living at the end of the peninsula could not have been easy, especially when large storms hit. Nantasket Avenue was not laid out until 1872, and passenger trains did not arrive until 1880. Even after both became fixtures, winter storms could halt all transportation service for days, even weeks. Hullonians needed to support themselves—and one another—in order to survive in their beloved village.

Without getting into jokes about earlier generations and their stories of the snowfall totals "in their day," the stories in this book will let the old days speak for themselves. There are tales of Christmas Day and Valentine's Day and even a Thanksgiving Eve storm; football games, fires and fowl hunting; shipwrecks, cotton cloth washing up on the beaches, the birth of Paragon Park and even supposed sightings of a famous kidnapper walking down our streets.

For many, the dropping temperature means it's time to leave Hull. For the rest of us, it's the time when life goes back to normal. There are about 10,000 of us that live here full-time. It's not the 250 or so that populated the community for most of the nineteenth century, but at times it feels that way, like you know every person you see on the street.

We all know one thing: there's a lot to see here, when Hull freezes over.

When Hull freezes over

On December 16, 1903, the Majestic Theatre in New York City opened its doors to reveal an unexpected development in the history of employment: the world's first female ushers.

The following day, Orville and Wilbur Wright soared into aviation history by launching the world's first large, heavier-than-air machine off the ground at Kitty Hawk, North Carolina.

Thirteen days later, on the thirtieth, Henry Ford organized the Ford Motor Company, Jack London's *Call of the Wild* hit bookstore shelves and a fire in Chicago's Iroquois Theatre claimed the lives of 602 people.

And in a year that had already seen an amazing number of firsts, including the first ever baseball World Series (Boston defeated the New York Giants five games to three) and the first "Nantucket" limerick ("There once was a man from Nantucket / Who kept all his cash in a bucket; / But his daughter, named Nan / Ran away with a man, / And as for the bucket, Nantucket." Please keep your sequels to yourselves.), December 30 was memorable for several more. Edwin S. Porter's *Great Train Robbery* became the first motion picture ever produced with a plot and made Max "Broncho Billy" Aronson the first ever movie star. Also on that day, President Theodore Roosevelt established the first wildlife refuge at Pelican Island in Sebastian, Florida.

In Hull, the month of December marked the first time in her life that Floretta Vining would spend the winter away from her room at the Parker House in Boston; instead she was stranded at Vining Villa on Stony Beach.

Although she had planned to get away from her summer home to follow her annual routine of elbow rubbing with the Boston elite, she had mistakenly underestimated the amount of time it would take her to complete her latest project: tearing down Cohasset's Black Rock House Hotel and piling up the timber in her Stony Beach backyard.

WHEN HULL FREEZES OVER

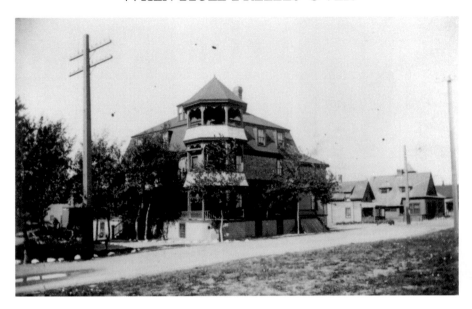

If one had to be 'trapped' in Hull in winter, what better place than at fabulous Vining Villa, at the corner of Spring Street and Nantasket Avenue?

She progressed through the fall of 1903 like any other, alternately slamming her neighbors through the written word in her weekly *Hull Beacon* editorials and notes columns and traveling throughout the northeast.

On October 2, she let it be known that "the lot of land owned by the Catholics at Stony Beach is allowed to go to waste and is full of all sorts of debris, and the weeds are allowed to go to seed and send the blueweed all over every neighbor's grounds. It is a disgrace to have a place look like that." A week later she left for Poland Springs, Maine.

On November 20, after a trip to Duxbury, she reported that "If one wants to have a pleasant ride in the electric cars you want to board the car that brings the children from Hingham to West's Corner. Of all the hoodlums one ever saw they live in that location. Have these children mothers? If so they had better give them instruction in deportment."

On December 4, as the *Hull Beacon* reported the Black Rock House as being "partly down," the town's most eminent meteorologists concluded that after examining all of the gathered scientific data, they could predict a robust winter. "The coons have three sets of hair, shingles have shown a thicker fuzz, flagstones have sweat-frost in the sunlit morning hours and

When Hull freezes over

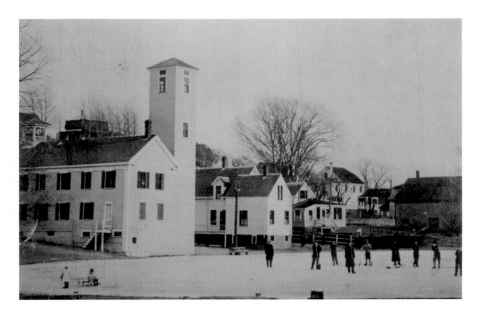

As far back as the Civil War, Hull has flooded the Village Park for skating.

squirrels have been putting away a big supply of nuts." That same week, the town flooded the Village Park, complete with electric lights and settees, in preparation for the coming skating season.

The following week brought the first true storm of the season, which conveniently deposited innumerable planks of Norwegian pine from the Clyde Line steamer *Kiowa* onto the shore; these treasures from the surf the townsfolk collected as firewood and as runners for sleighs. By Christmas, the temperature dropped below the freezing point, allowing the soldiers of the 83rd Coast Artillery stationed at Fort Revere to impress the local maids with their skating abilities at Straits Pond at the southern end of the peninsula. Soon thereafter, the bay froze over as well.

To ring in the new year of 1904, Captain Alfred A. Galiano treated the town's three oldest residents—Samuel James, John Smith and his own father, Andrew Galiano—to a meal at his expense.

On January 3 at 12:45 a.m., the schooner *Belle J. Neale* ran ashore at Point Allerton. Captain William Sparrow and crew, aided by Hull's famous volunteer lifesavers, rescued seven men by boat through a raging nor'easter and offered them shelter at the Point Allerton U.S. Lifesaving Station. Food was prepared by Mrs. Sparrow, and clothing donated by the Women's

National Relief Association. For weeks thereafter, Floretta Vining listened for the shouted expletives that always preceded the splash of a wrecker falling into the frigid water off Stony Beach, a failed attempt to retrieve a portion of the schooner's cargo of oranges, turpentine and cotton cloth.

The following day the snow had piled so high that Hull had once again become an island unto itself. John Wheeler, teamster and member of the town's board of health, worked as hard as he could to keep the streets of Hull Village clear, but the folks at Allerton found their homes surrounded by snowbanks measuring up to ten feet in depth. The wreckage from the *Belle J. Neale*, the *Allen H. Jones*, the *Poe* and the *Kiowa* all froze into the sheet of ice that now stretched all the way across Quincy Bay and reached out into the inner harbor.

Against this backdrop, Floretta Vining first met Lavinia Isham, the Hampton Head Hermit. Eva, as she was known, lived nearly destitute on a lot along the Weir River. The week of January 15, 1904, as recorded in the *Hull Beacon*, the court at Hingham called her in to answer to charges of "failing to provide proper sustenance for seven cows, a horse and a number of hens." She had also become the subject of a still-prevalent suburban legend that claims people who avoid all contact with others must be superintelligent: "Miss Isham is said to be highly educated."

Vining, whose heart seemed to warm as the temperature continued to plummet, saw the perfect opportunity to practice her personal philosophy of helping those who agree to help themselves. "I never knew that there lived in Hull such a person as Miss Lavinia Isham," she wrote in the *Beacon* on January 29, 1904. "I immediately went to her assistance, and made a good cash offer, taking all the animals to my home, and then if she would take care of the poultry for me or sew, I would employ her…I am sure she is not in her right mind. No person could talk and do as she does and be sane."

Isham apparently never took Vining up on her offer, as soon the Hull police sent Officer Francis S. James to arrest her. "It is said Miss Isham nearly masticated the deputy sheriff, but that Officer James' soothing influence is so great with the ladies that she accompanied him to Plymouth as docile as a lamb. He gave her into the care of Sheriff Porter, who assumes charge." More than two decades later, Francis James would be the first Hull police officer to die in uniform.

By the end of January, Vining felt that she could no longer hold in her feelings for the beautiful sights to be seen in Hull in the winter. "Had any one told me I should winter in Hull, I should have indeed been amazed, and yet the time has gone along, and here we are at the month of

When Hull freezes over

February," she wrote in her editorial "A Winter in Hull" in the January 29, 1904 edition of the *Hull Beacon*.

> *Really, if any one was partly ill and had to stay home, they could never find a place to winter equal to Stony Beach, Hull, with houses with stone cellars and furnaces and steam heaters. And such a view! You can't keep your eyes off the ocean. Ships, steamers, large and small, one mass of ice. You could not imagine they could glide along so fast on the ocean. I have indeed seen sights that I never dreamed of. I am not much given to looking out of the window, but I am looking out nowadays all the time.*
>
> *There have been so many storms that there is a constant excitement. The U.S. crew of lifesavers are on the patrol, and with the prospect of wealth thrown in by the sea, all of the men of Hull are out patrolling, and when a vessel is sighted in distress, the excitement begins.*
>
> *Never has there been any such amount of snow in the town in years and there have been five weeks of continuous sleighing…for views on the ocean and around about, Hull has no equal.*

One young woman who had just recently moved to Hull commented on the train over from Allerton to Stony Beach, "You say all this side is water

Lying on its side today beneath the waves, the old Point Allerton Beacon is still discernible.

17

when spring comes and all this side is water: would you please tell me where the land is?" (*Hull Beacon*, January 29, 1904)

Just a week after her heartfelt editorial, Vining's own heart began to return to its usual icy condition, as her pen once again found the poison inkwell. "January 1904 can be remembered as having given us simultaneously 36 inches of snow and the unpleasant word 'yeggmen.'" (The word *yegg*, or *yeggman*, slang for safecracker, actually first appeared in the *New York Evening Post* on June 23, 1903. Apparently it took a while to reach Hull.)

By February 19, Vining had regained her magic touch entirely. "Young girls should not be housed by a married woman and play cards into the morning and have big suppers. We may tell the names. Mothers, know where your daughters are after 10 p.m." Next came a sentence that will live through the ages, the words that should have been carved right on Vining's tombstone as the motto of her personal mission in life: "The night should not be filled with deviltry in the town of Hull."

Soon the ice and snow began to thaw, and the green and brown of the Hull peninsula once again burst forth from beneath winter's spawn. Floretta Vining achieved her goal of demolishing the Black Rock House, leaving the land on which it had stood as raw and beautiful as nature had intended it to be. As early as March, Vining began to spout her annual spring mantra that the coming season would be the most prosperous ever at Nantasket Beach.

Yet for Vining, life would never be the same, for she could no longer see Hull as simply a summer resort. Through the blinding snows she had seen sleighing parties merrily riding through the streets, children skating at the Village Park and the industrious people of Hull making their winter living from the sea. For once in her life, she had seen how wonderful and engaging life can be when Hull freezes over.

No sweep this year

It all began with cheating. It was in 1823 on the athletic fields of the English school Rugby that young William Webb Ellis decided to catch a kicked soccer ball and make a reckless dash for the opposing team's goal. The rest of the players on the field stood and stared in utter shock and bewilderment as Ellis raced by them. They vilified him at first for his unsportsmanlike actions, but then, as tempers cooled, it became quite apparent that the rogue defender had struck on quite a novel idea.

The first intercollegiate association football (or soccer) game played in the United States contested Princeton against Rutgers in New Brunswick, New Jersey, on November 6, 1869. At that time, no school in the country, save for Harvard, played any version of rugby. The only competition Harvard could find on the continent was a team from McGill University in Montreal, Quebec, which played a purer form of the game than the mixed rugby-soccer then played at Harvard. The two squads met on May 14 and 15, 1874, in Cambridge, Massachusetts.

The following year, on November 13, 1875, Harvard coaxed its archrival, Yale, onto the field for the first installment of what is still today called the Game. Yale fell in love with rugby but thought that instead of fifteen men per side, there should be only eleven.

Five years later, in 1880, the American game of football began to take shape. Led by the creative sports intellect of Yale's Walter Camp, the Intercollegiate Football Association drew up a revolutionary set of rules that year. Instead of the rugby scrum, in which players locked their arms around their teammates' necks and pushed head-to-head against their opponents while trying to heel the ball back to a teammate who could pick it up and run forward with it, Camp devised the line of scrimmage. This created the notion of one team having possession of the ball and produced the glorified

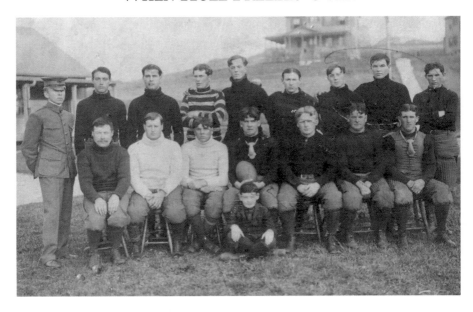

Football players of the late nineteenth and early twentieth centuries wore baggy pants, horsehair shirts and long hair, as shown here by a Fort Revere team.

position of the quarterback, who received the snapback (a heeled kick from the center) but could not run with the ball.

Camp also pushed for an eleven-man formation on the field: seven men on the line, one quarterback, two halfbacks and one fullback. In 1882, the association adopted a series of downs, giving a team three chances to cover 5 yards or forfeit the ball. At that point, the 110-yard fields were marked with horizontal lines every 5 yards, giving them the appearance of a gridiron.

In 1883, the association standardized its scoring system, with one point for a safety, two for a touchdown, four for a goal after touchdown and five for a goal from the field. A few years later, it boosted the touchdown to four points. In 1888, tackling below the waist was permitted for the first time, and linemen were outlawed from extending their arms when running interference. Because of that rule, the men on the line, who formerly spread themselves across the width of the field, crunched down shoulder-to-shoulder, with the backs falling in behind them in a T formation.

The ball itself still bore more resemblance to a soccer ball than today's football, and the athletes bore little resemblance to the stars of today. Pads were for wimps, and the only head protection players wore was the hair that they grew out from the first of June in preparation for the season. Players

No sweep this year

wore baggy pants and tight-fitting shirts, some made of horsehair so as to yield no firm grip. Linemen were selected for their boxing and wrestling capabilities. (OK, so some things have not changed at all.)

Such was the state of the game of American football when the Hull Athletic Association met the Hingham Athletic Association on the slippery tundra of the Hingham Agricultural grounds on Thanksgiving Day, 1897. The two squads had clashed twice before. Earlier in the year they had played to a scoreless tie, but a year before on Thanksgiving Day, 1896, Hull won big, 10–0. Hingham claimed it to be an unfair contest, as Hull had imported a number of established college stars to ensure victory.

The 1897 Hull players outweighed their Hingham rivals by a large margin. Such always seemed to be the case: when Hull put out the challenge in 1898 for any team averaging no more than 125 pounds to play, it found only one opponent all autumn, Thayer Academy, whom Hull beat 11–0. Duxbury, who originally agreed to send a team, backed out when the players realized they would be seriously outsized by Hull.

Hull's eleven that day featured some of the small town's best-known personalities. Jim Dowd, formerly a surfman with Joshua James and then the owner and operator of Knight's Express livery service (which he later sold to Warner Dailey and Newton Wanzer), anchored the line at center. He had already gained the unofficial title of the strongest man in Hull.

Eugene Mitchell Jr., himself a renowned lifesaver, at left tackle, was one of two Mitchells in the starting lineup, standing beside his cousin Henry Webster Mitchell, who played left guard. In February 1898, Eugene would be voted the handsomest man in Hull.

The captain and starting left halfback was Clarence Vaughn Nickerson. Educated in the Barnstable public schools and then at Bridgewater Normal, Nickerson was appointed principal of the Hull village schools when he was nineteen, served as town moderator when he was twenty-three and would remain a central figure in Hull politics for the next half century. The rest of the starting lineup was rounded out by Lester Lowe at right end, Richard T. Hayes at right tackle, one of the Galiano brothers at right guard (no first initial given), aspiring doctor Walter H. Sturgis at left end, Surfman Martin Quinn at quarterback and ringers Taylor of Greenwich Academy and McBride of MIT at right halfback and fullback, respectively.

At ten that morning, referee George James called for the game to start. The previous year's referee, Dr. William Harvey Litchfield, a once and future state representative from Hull, had not been invited back on the basis of football incompetence. The *Hingham Journal* reported on December 4,

Clarence Vaughn Nickerson, playing for Hull in the ongoing Hull-Hingham football rivalry, began teaching at the Hull Village School at age nineteen.

1896 that Litchfield had actually allowed Hull to complete a forward pass, an incorrigible play that would remain illegal for the next decade.

Hull kicked off to the ten, but Hingham could not move the ball past the thirty-five. Hull lost possession quickly, turning the ball over on downs, and Hingham began to march steadily downfield. Under the current rule system, without forward passes, every play looked like third down and one yard to go. There were only two options: run the ball up the middle or run around the ends.

But because there were no limitations as to the number of men that could be in motion before the ball was snapped, teams tried almost anything. Most deadly and injurious was the flying wedge. The quarterback would stand back ten yards and before receiving the snapback would motion for his men to run back thirty yards. They then would turn, run downfield and build up momentum as the ball was snapped and form a V around the ball carrier.

No sweep this year

With such speed built up, they would crash through their opponents, causing injury after injury. Things got so bad that President Teddy Roosevelt called a college football summit in 1905 to try to find a way to curb the sport's propensity toward violence and brutality.

The most popular way to stop the flying wedge was to dive under the lead blocker and open a hole in front of the runner for other defenders to run through. One man, Pudge Hefflefinger of Yale, who at six feet four inches towered over all of his opponents, found it easier to leap over the lead blocker and come down on top of the ball carrier. Hefflefinger, a three-time All-American, also had the distinction of being the first documented professional football player, having accepted five hundred dollars from the Allegheny Athletic Association on November 12, 1892 to play against the Pittsburgh Athletic Club.

Hingham's mass-momentum plays could not be stopped, though. The *Hull Beacon* reported that "Hingham secured the ball and worked it down the field by superb interference," of course noting that Hingham had "the advantage of going down hill" (November 27, 1897). The last fact was conspicuously absent from the *Hingham Journal*'s coverage. The *Journal*'s more detailed account described the inevitable scoring play by saying that Hingham "pushed Keenan through the line for a touchdown." At that time, it was legal to push, pull or carry the ball carrier into the end zone.

John W. Heisman, founder of the Downtown Athletic Club, summed it up this way: "Sometimes two enemy tacklers would be clinging to the runner's legs, and trying to hold him back, while several team-mates of the runner had hold of his arms, head, hair or wherever they could attach themselves, and were pulling him in the other direction" (Allison Danzig, *Oh, How They Played the Game*, 72).

Hingham could not convert its goal after touchdown, and at halftime, after twenty-five minutes of play, the score stood at Hingham 4, Hull 0.

To start the second half, Hingham kicked off, but the ball glanced off kicker Tierney's foot and skidded up the middle of the field toward Eugene Mitchell, who downed the ball on the fifty-five-yard line. Hull could do nothing to advance the ball, though, and Hingham took over on downs.

Hingham immediately called a guards-back play, with fantastic results. Before the snap of the ball, quarterback Spring called for his two guards, Breen and Burdett, to line up behind him in the backfield. The tackles and ends then tightened up their formation, and the ball was snapped and handed to Breen, who barreled down the field. "It was a most satisfying sight to the Hingham rooters to see him gain ten yards with as many Hull

men on his back as there was room for any back to possibly hold" (*Hingham Journal* December 3, 1897).

With about ten minutes to play, a fearful collision between Dick Hayes of Hull and Kelley of Hingham knocked Hayes unconscious. The young Harvard law student was forced to leave the game, replaced by Stillman Dexter Mitchell. (A player could not leave any game unless seriously injured.) Bugs Mitchell, as he was known, had lost most of his front teeth in a similar situation in the 1896 game but had stayed in until the final whistle. Hull's front line, from left to right, was now Mitchell, Mitchell, Dowd, Galiano, and Mitchell.

Hingham retained possession of the ball for the remainder of the half, as the Hull men valiantly defended their goal. When the final whistle sounded, the ball sat six inches from the goal line. A moral victory for Hull perhaps, but the game was lost.

Ten minutes later, when Dick Hayes woke up, the Hull team left for home. Apparently, the men had not planned to leave in defeat. "Somebody of prying nature discovered concealed beneath the seats of the coach quite a number of those useful household articles, brooms. Of course, the Hull boys, knowing in what condition the ground would be, brought them along for the obvious purpose of cleaning the field. Nobody could be evil-minded enough to even imagine that they, on the strength of their confidence to win the game, had brought them to 'do the town'" (*Hingham Journal* December 3, 1897). Apparently, taunting was not yet illegal either.

As the Hull eleven trudged back up the peninsula, they vowed to get their revenge on the next Thanksgiving Day.

Prelude to the Portland Gale

The year 1898, to many, marked the birth of the American century, a century in which the United States finally ventured into the international race to be its own imperialistic empire, starting with its war with Spain, and broke away from its traditional isolationist beliefs. By the end of World War I, the Unites States would be recognized for the first time as a world power; by the end of World War II, it would be *the* world power.

As with any pivotal year in history, the broader national and international changes that affected the world inevitably caused variations in the everyday lives of small-town Americans. It is in these years—1776, 1848, 1898, 1929, 1941, 1963 and so on—that we can most vividly see the patterns of social change. Vestiges of the changes that took place in Hull in 1898 remain today.

In Hull, the year began as could be expected: quietly. With all of the town's summer millionaires locked into their warm winter residences in the city, the year-round populace celebrated the coming of the new year by reflecting on the events of 1897: the deaths of twelve residents, an unusually high number for the town; the warm July night that an alligator from a German circus decided to break free and walk Nantasket Beach; and the Private White case, concerning the mysterious death of a young soldier stepping off a boat at Pemberton. Soon, though, the year 1898 began to form its own identity.

By January 15, the surfmen at Point Allerton U.S. Lifesaving Station had reported several unnerving visitations by a phantom surfwoman on their westward patrols to Pemberton Point. That same week, the Hull Yacht Club staked out the grounds that would later become the Hull Golf Links. And lifesaver, steamboat captain and Civil War veteran Louis G. Serovich nearly lost his life, falling through a hole in the ice at Pemberton, only to be saved

literally by a whisker. Captain Alfred A. Galiano, standing nearby, hauled his friend out of the water by grabbing on to the first thing he could get his hands on: Serovich's beard. Although Serovich denied the story, he had to live with jokes like the following for months: "Perhaps the reason why there were no lives lost during the recent high tide is because so many are letting their whiskers grow" (*Hull Beacon* January 29, 1898). (Serovich was quite the jokester himself; one of his more famous was "Take a certain animal out of Cohasset and there will be little of CohASSet left.")

The "recent high tide," though, was no joke. The storms of late January consistently cut off Hull Village from the rest of the peninsula, and the town's old-timers declared the tides to be the highest since the Minot's Light Gale of April 1851, interestingly bypassing the great storm of November 1888. Hull's lifesavers worked day and night, rowing throughout the streets to transport citizens to higher ground and rowing out into the swollen harbor to aid distressed mariners. The weather completely overshadowed the destruction of the USS *Maine* in Havana Harbor on February 15.

Soon, though, the news of the war with Spain consumed the town. Although only one young man from Hull joined in on the conflict in Cuba— Charles W. Knight, aboard the USS *Marblehead*—private citizens held flag-raising ceremonies, hotel proprietors held bonfires for the purpose of burning Spanish generals in effigy and the Life-Saving Service ordered Joshua James to stay at his post for the summer to scan the horizon for enemy warships. As the United States steamrolled its way to victory, the townsfolk dropped all fears of the Spanish navy bombing their hotels and cottages and turned their attention to the promise of a lucrative summer season.

Thousands of bicyclists flooded the beach for the summer, to the delight of Colonel Albert A. Pope, the father of American bicycling, and a member of Hull's world-famous yacht club. A second, smaller yacht club began operations that summer as well: "A new yacht club has been organized in this village designated as the Hull Mosquito Yacht Club. Entrance fee $1.00, entry fee for each race, fifty cents. Races to be held every other Saturday off James' Bros. pier, commencing June 25, 1898. No yachts admitted over 17 feet, water line. Special attention is called to the fact that this is the only yacht club in the world admitting women to membership" (*Hull Beacon* 4 June 1898). In 1882, the Hull Yacht Club had become the first such organization in the world to admit an African American to membership, affectionately but unfortunately known around the club as George "Nigger" Garraway.

The town, under the guidance of "Boss" John Smith (the town's notorious political leader), and continually prodded along by Floretta

Prelude to the Portland Gale

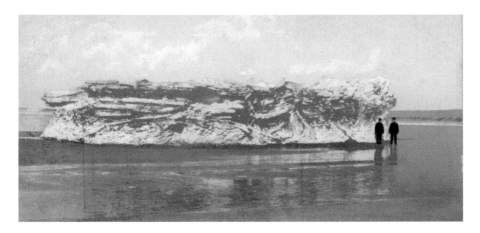

Above: Strange things float into town when Hull freezes over.

Below: The average summer visitor to Nantasket Beach might not have recognized the place during the winter when the biggest storms hit.

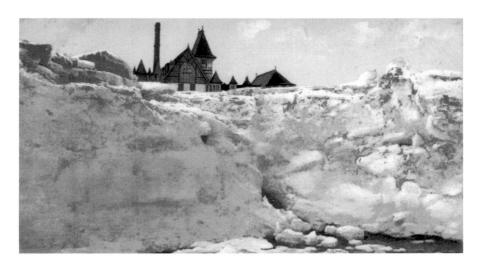

Vining, progressively pushed on toward the new century. Six thousand tons of riprap reached Allerton Hill for the construction of seawalls just weeks before the residents of Western Avenue heard the news that they would soon have running water, through pipes connected to Accord Pond in Hingham.

One devoted Hull resident had already seen the future and decided to share his or her vision with David Porter Mathews at the *Hull Beacon* on August 4, 1898:

When Hull Freezes Over

Mr. Editor, would it not be an excellent plan for visitors and Hullonians to work together to secure the John Boyle O'Reilly estate and present it to Hull for a public library? The library is fast outgrowing its present quarters in the school building and besides the room is needed by the school which is growing rapidly and it seems to me, and I think many will find loving echo in their hearts, that it is eminently fitting that the home which John Boyle O'Reilly so fondly loved should be used as a center for the dissemination of knowledge.

It took fifteen years, but in 1913 the town finally shared this writer's vision and moved its library collection to its current location.

The beach at Nantasket offered a number of new attractions for the 1898 summer season. The town's first "Funnyscope" could be viewed just outside the Hotel Tivoli, featuring a passage through the House That Jack Built and a ride through the Rocky Mountains. The Chutes, an early waterslide across from the Rockland House Hotel complete with its own brand-new dance hall, outshone all other attractions in town. "An evening at the Chutes seems like one spent in Fairyland. The illumination, the sparkling rushing and the steady downpour of water on the slide or sluice way and the soft strains of music give the entire environment this effect. One almost feels himself in another world, and in a sense he is"(*Hull Beacon* June 25, 1898). The Chutes drew thousands to Hull to earn the right to proudly boast, "I shot the Chutes at Nantasket Beach."

Sportsmen and the sporting life thrived along the peninsula. Joe Lannin, proprietor of the Fairhaven Hotel, fielded his Fairhaven Nine, taking on all comers in baseball. A decade and a half later, Lannin would consolidate his hotel earnings and purchase another local ball club, the Boston Red Sox.

The end of the summer season brought with it the usual Labor Day festivities at the Hull Yacht Club. That year's events included a five-hundred-yard canoe race, a swim relay, a blindfolded dory race, a water baseball game between the club and the Boston Athletic Association and a lifesaving exhibition by Joshua James and his crew.

For those young men who hoped to someday participate in such sporting events, the *Hull Beacon* offered this advice: "How to Become Muscular: Walk a great deal, carrying something always in the hands. This develops the arms. To roll a hoop might be good if one were brave enough to do it in public. Practice lifting a little every day. Eat meat, drink milk, and practice bending backward, forward and sideways every day. At night rub about a tablespoon of brandy or rum into your skin on the under and tender part of the arms" (April 30, 1898).

Prelude to the Portland Gale

In 1898, a forward-thinking reader of the *Hull Beacon* suggested turning the old John Boyle O'Reilly cottage into a public library.

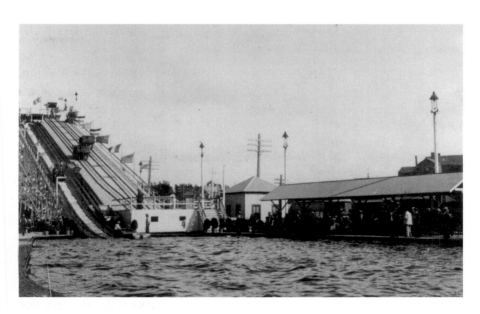

In a summer of fun and frivolity, the bravest of them all climbed to the top of the slide to 'shoot the Chutes' at Nantasket Beach.

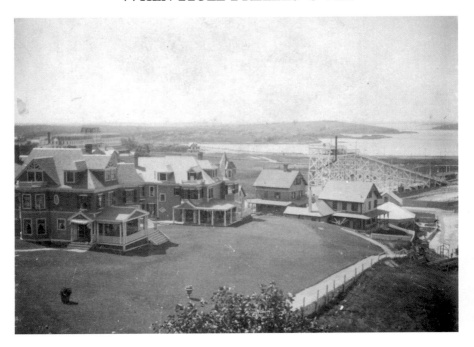

This view of the Chutes from Atlantic Hill (note the Rockland House off to the left) was one of the last photos taken of the famed ride before the Portland Gale arrived in November 1898.

The end of the summer season also brought back the scary and unpredictable weather of the late winter. In late August, the town experienced its worst hailstorm to date, losing 3,000 windows to the barrage, including 500 at the Pemberton Hotel ("the coolest place on the coast") and 185 on the property of Floretta Vining. In early September lightning struck the Oregon House stable, shocking attendant John Hayes and peeling the covering off a whip.

The first frost of the winter season came relatively early, in the first week of November, yet for the most part, temperatures remained considerably mild through the end of the month. The Hull football team, led by Harry Cleverly, challenged any teams "averaging about 125 lbs." to come to Hull for a match. The team arranged two games that year, beating Thayer Academy 11–0 and accepting a forfeit win from Duxbury, who claimed Hull's 125-pound gridiron giants were simply too big to handle.

On November 9, Reinier James Jr. and his cousin Samuel rode off on their bicycles for a planned two-week trip to New York City. They returned the week of November 26.

30

Prelude to the Portland Gale

On November 22, Joshua James celebrated his seventy-second birthday, and two days later the town celebrated Thanksgiving. The next morning, James would be reminded that that day, November 25, 1898, marked the tenth anniversary of his greatest moment, the night he led Hull's volunteers to the rescue of twenty-nine mariners on six vessels. It was a moment he hoped to never have to repeat.

The next evening, around half past seven, a few harmless snowflakes trickled down out of the sky as Joshua James watched from the interior of the Point Allerton station. By midnight, the most powerful and destructive storm to ever hit Hull's shores, the Portland Gale, would be attacking with all its fury. Old Boreas was coming to Hull to shoot the Chutes.

Storm of the century

At 7:37 on the evening of Saturday, November 26, 1898, a harmless snowflake trickled down from above and landed on the road in front of Point Allerton U.S. Lifesaving Station. From within the station's walls, seventy-two-year-old keeper Joshua James had watched the oncoming storm build. The afternoon had been like many others in November, cloudy and a bit chilly. Yet the continued swarming of those dark clouds into the early evening hours signaled to the fifty-seven-year veteran storm warrior that Mother Nature had decided against his relaxing in his older years.

More snowflakes followed the first, and as the temperature continued to descend with the darkness of night, old Boreas began to blow with all of his might. By ten o'clock, two inches of slush covered the ground, and the wind had built to a force strong enough to knock a man off his feet. Over the next two hours the storm that would forever be known as the Portland Gale intensified to form a hellish symphony of wind, precipitation and waves.

At eleven o'clock, Consolidated Coal Company's Barge no. 4, anchored off Point Allerton Bar, parted from its mooring and began to blow toward Toddy Rocks to the southwest. Shortly after the tug *Cumberland* had left the no. 4 to ride out the storm, barge captain Charles Abergh blew four short blasts on his whistle three times to call the tug back, but this garnered no response. He would have continued to blow for help had the seas not endangered his ship's fires. Six hours later, around five in the morning, the barge crashed on shore in a cacophony of howling wind, roaring surf and the screams of dying men.

When it struck, engineer Charles Nelson and two crewmen simply known as Alfred and Fred disappeared beneath the ocean's frothy surface. Disoriented by the darkness, and battered about relentlessly by the surf, they would never be seen alive again.

When Hull Freezes Over

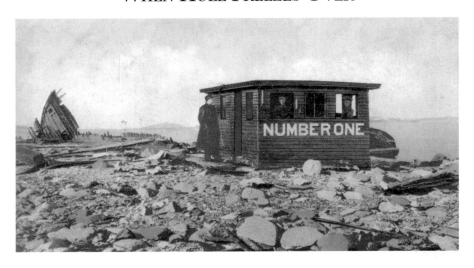

Consolidated Coal Company's Barge no. 1 was just one of the many casualties of the Portland Gale in Hull.

Captain Abergh and his steward, John Vanderveer of Baltimore, survived the disaster. Hugging the base of the cliff below Battery Heights (in front of the Jacobs School today), they hurriedly and blindly stumbled westward along the shore, soaked by the breaking surf, until they reached a small cottage. Pounding on the door and hollering above the din of the storm, they alerted the owner, Amber Cleverly, who hastened to let them in. They had barely begun to warm themselves in front of the fire before the entire house tilted on its foundation. Gathering his family and the stranded sailors, Cleverly led them all to the annex of the nearby Pemberton Inn.

At about three in the morning on Sunday the twenty-seventh, a surfman on patrol from the lifesaving station spotted a three-masted schooner at anchor in Nantasket Roads about a quarter of a mile out from Stony Beach. The gusting northeast winds, now reaching seventy-two miles per hour, pushed the vessel with force enough to drag its chains across the channel until it came within five hundred yards of the shore, a third of a mile to the northwest of the station.

Unable to see clearly through the blizzard, Captain James decided against launching a lifeboat. He instead told his crew they would wait until daybreak and then use the beach apparatus to effect the rescue of whomever should be on board the schooner.

34

Storm of the century

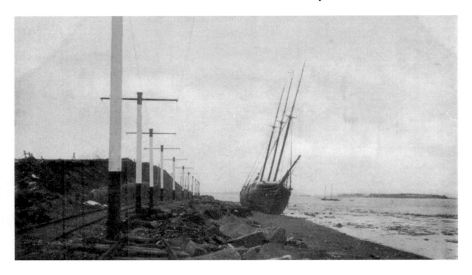

The rescue of the crew of the *Henry R. Tilton* proved to be one of the lifesavers' most difficult tests during the storm.

At first light, the captain fired the station's Lyle gun, landing a line across the *Henry R. Tilton*'s jib stays. The surfmen on shore, now joined by Massachusetts Humane Society volunteers Osceola and Francis James, Eben Pope, Louis and Joseph Galiano, William Mitchell, and John Knowles, tied a whip line to the shot line and motioned for the sailors to haul it out to the schooner. But the incredible amount of wreckage and seaweed between ship and shore made it an impossible task. Dragging the line in, the lifesavers set up a second shot, which the captain successfully steered across the spring stay, but unfortunately it proved to be out of the reach of the tiring mariners on board. Finally, a third shot struck the rigging and clanged onto the deck.

After tying off the whip line and hawser, the sailors one by one stepped into the breeches buoy. Because of the positioning of the boat, the lifesavers on shore were forced to stand dangerously close to the surf, which at times swallowed them whole, equipment and all.

As the vessel continued to drift in the wind, the lifesavers found it necessary to reset their lines before each man came ashore. After three hours, all seven men—Captain H.S. Cobb, mate Frank Randlett, and crew Henry Henderson, Charles Colson, L.M. Keane, William Healsley and John Hanson—stood on firm ground, pulled from sure disaster.

Yet even before the lifesavers had finished their work with the *Tilton*, word reached Captain James that a coal barge just to the west was headed for

35

shore. Surveying the damage in front of the station, James knew that to attempt to pull the Life-Saving Service's second beach apparatus up the coast and run the gauntlet of pounding surf, tangled masses of wire and wildly flailing telegraph poles would be impossible. He called to his son Osceola, the Humane Society boat keeper, who agreed to send a team of horses to collect the society's Hunt line-throwing gun.

At 10:40 a.m. the tides reached the highest point in living memory. At Windmill Point water rushed into the annex of the Pemberton Inn, sending Amber Cleverly and company scrambling for the second floor. Water soon covered the entire Pemberton area and poured into Hull Village, where it formed a white-capped lake.

Between Allerton Hill and the lifesaving station, the seawall built by the railroad company valiantly accepted the worst the storm had to offer, bending but never breaking. Were it not for the wall, the isthmus between the two points would have been washed over completely, leaving Hull Village an island unto itself. Perhaps as revenge for thwarting the storm's desire for destruction, the wind instead chose to blow apart the railroad's Stony Beach station.

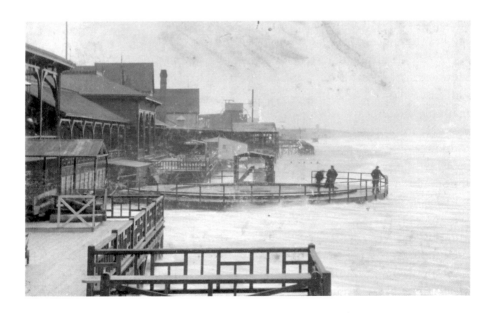

The storm raged right through the weekend of November 26–27, raising tides to levels not seen since 1851.

Storm of the century

From Allerton Hill to Strawberry Hill, the ocean claimed everything from the beach to the County Road (Nantasket Avenue), at a depth of at least two feet. Houses twisted from their foundations or fell over completely, and railroad tracks warped before the sea's fury.

From the Kenberma section (south of Strawberry Hill) to Whitehead (Sunset Point), ocean and bay met, turning everything from Strawberry Hill north, at least for a few hours, from peninsula to island. As the water barged through windows and doors uninvited and doused fires, townsfolk fled in boats toward the hills.

At the south end of Nantasket Beach, bathhouses floated away to sea, and the verandas of the Ocean House, the Rockland Café and the Hotel Tivoli splintered. The promenade between the café and the Hotel Nantasket, a thousand feet long, collapsed, as did the toboggan slide, and the newly built Nantasket dance hall, the Chutes, the ultimate symbol of all the gaiety to be found in a Nantasket summer, struggled to remain standing as fragments broke away with the wind.

At Green Hill, sixty cottages blew off their foundations. Some landed in the streets on their side, while others deposited themselves upside down in Straits Pond.

Almost two hours earlier, at nine, the coal barges *Virginia* and *Lucy R. Nichols* tore from their anchorage off Nantasket Beach, having been left by their tug, *Underwriter*, to ride out the gale. The *Virginia* broke apart and succumbed to Neptune's call, with all aboard perishing. As the *Nichols* blew toward Black Rock at Stoney (or Crescent) Beach, on the Hull-Cohasset border, Captain John Petersen and an anonymous crewman leapt overboard, taking their chances with the sea, which made sure they would never walk the earth again.

In probably the most amazing instance of pure luck throughout the entire span of the storm, a mast from the disintegrating *Nichols* fell directly across to the small island, creating an extremely temporary walkway to safety for the remaining crew members. The three men—John Soderstrom, B. Fray and Oscar Colson—dashed across the mast toward the only available shelter, a gunning hut, as the sea swallowed their vessel behind them. They entered the hut, built a fire and waited.

Somewhere off Hull's shores, the *Minnie Stowe*, *Abel E. Babcock*, *James H. Hoyt*, *Baltimore* and countless other vessels disappeared without witnesses.

By eleven that morning, Joshua James and the lifesavers reached the scene of the next impending disaster, that of Consolidated Coal Company's Barge no. 1, the traveling companion of the no. 4. James fired two shots toward

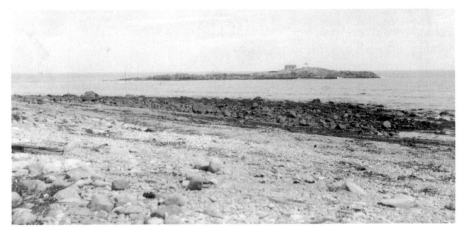

Cohasset's Black Rock served as sanctuary for one ship's crew as the Portland Gale attacked the shoreline towns.

the foundering vessel before he realized that the sea had no intention of allowing the barge's crew to be rescued by normal means. A mere plaything of the wave tops, the barge split in half, and then its pilothouse broke away. The five men on board—Captain Joshua Thomas, Charles Mackall, Jacob Hines, Alfred Nickerson and Paul Steffanowski—clung on for dear life as the pilothouse headed for its destiny on shore.

Improvising, Captain James turned to his collected storm fighters, whose numbers had grown by the addition of selectman and volunteer Alfred A. Galiano and young Harry Biram and his father, the Reverend James Biram of the Village Church, who offered coffee for the men and prayers for the victims. Captain James called for volunteers to tie ropes around their waists and wade out into the surf to grab the victims as they floated in. On shore, the rest of the mixed crew of the government's hired men and the local volunteers clutched firmly to the other ends of the ropes, prepared to haul their compatriots to safety at the first sign of real danger.

As the lifesavers worked themselves into position, a giant wave lifted the pilothouse to its apex and then slammed it heavily onto the rocky beach, tossing the sailors in various directions. The lifesavers hurried to each man and held on tight, bracing for the next wave strike. When it came, the torrents of water carried the group up the beach to a point where they could scamper to safety. Louis Galiano, struck by a flying piece of debris, suffered a deep bruise on his leg and retreated to his home for care. He became the first casualty in the lifesavers' war against the gale.

Storm of the century

Looking around for the nearest available shelter, Joshua James spotted the cottage of Frank Burrill. Realizing the inhabitants had fled, he ordered his men to break the door down to gain access to the home. Once inside, the lifesavers stripped the sailors of their wet clothes, wrapped them in blankets, built a fire and fed them hot whiskey drinks. When he could speak, the barge captain violently cursed the master of the tug, saying that if he and his men had perished, the blame would all be on the *Cumberland* captain's head.

Returning to the station in the early afternoon, James made arrangements for a team of horses to be sent to retrieve the sailors at the Burrill cottage. Word soon arrived that the two survivors of Barge no. 4 also needed attention, so the captain sent another team to the Pemberton Inn to bring them back to the station as well. Joshua's wife, Louisa, and Mrs. George F. Pope spent every ounce of their energy caring for the lost and stranded sailors, now totaling fourteen.

At 1:45 p.m. on Sunday, the snow stopped falling. Taking advantage of the clearing skies, the captain reached for his spyglass. He instantly noticed a three-masted schooner ashore at Little Brewster Island, sharing its perch

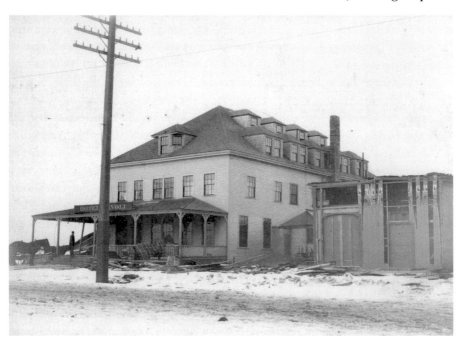

Many places, like the Hotel Tivoli on Nantasket Beach, would never be the same after the Portland Gale.

with America's oldest lighthouse, Boston Light. Unable to discern whether or not light keeper Henry Pingree had hoisted his prearranged distress signal and uneasy about launching a boat into the continuingly choppy seas, James sent his men on their usual beach patrols and opted to check the lighthouse again at first light.

Meanwhile surfman no. 1, George Franklin Pope, the captain's nephew, observed a figure gesturing wildly through a chamber window down the street. Launching a dory from the boat room, he rowed to the home of Warner Dailey, whose family had fled, and escorted him to higher ground.

At three in the afternoon, *Hull Beacon* editor and *Boston Globe* correspondent David Porter Mathews set out from Pemberton on foot to march the length of the peninsula to North Cohasset, to send his correspondence off on a Boston train. At four the snow began to fall again, and although he had listened to the fears of the townsfolk, who believed the evening's high tide would be more destructive than the morning's, he pushed on. Darkness fell once again.

The lifesavers sidestepped wreckage the entire length of their patrols, only to find that their keyposts at both Pemberton Point and A Street, where they usually punched their patrol clocks, had washed away. At ten that evening, the snow stopped again. Over the course of twenty-four hours, the skies had dumped twelve inches at Nantasket, and the wind had pushed it around to randomly form drifts as high as ten feet. At eleven o'clock, Mathews finally reached his destination, only to learn that the train would not be running. With his face badly beaten by the icy winds, and having gone without food for most of the day, he found himself a shanty and called it a night.

At Little Brewster Island, the crew of the schooner *Calvin F. Baker* had clambered into the rigging as the aft deck crumbled beneath their feet. During the night, their pitiful cries for help kept Keeper Pingree's wife awake and in a state of horror, the stress of which would eventually kill her. Fifty-seven-year-old first mate Burgess Howland lost his strength in the freezing cold and dropped into the ocean, dead. Soon thereafter, Second Mate R. McIsaacs met the same fate. Steward Willis H. Studley froze to death in place.

As the sun rose on Monday the twenty-eighth, James again looked out to Boston Light. Sighting the predetermined distress signal, he roused his men and ordered them out to Humane Society boat station no. 17 on Stony Beach, where they met Osceola and his volunteers. Joshua and his surfmen—George Pope, Francis Mitchell, James Murphy, Fernando Bearse, James Curran, William Peel and Hulver Gillerson—joined four volunteers

aboard the surfboat *Boston Herald* and pulled until they could hail a passing tugboat, the *Ariel*.

The tug captain hitched a line to the surfboat and brought the lifesavers in as close as he dared; then he waited as they rowed in past the breakers and settled alongside the *Baker*. When brought down from the rigging, Captain Megalthin told the crew of his ship's fate, that it had stranded on the rocky island at three o'clock on Sunday morning, nearly thirty hours earlier. Two of his men were none the worse for their ordeal while two others had badly swollen and frostbitten feet. Prying the dead steward from the rigging, the lifesavers brought the victims to the tug, where the captain had hot whiskey waiting. James and his men returned to the station at 10:30 a.m.

Meeting them at the door, Alfred Galiano informed the captain that a group of what looked to be five men had set up a distress signal at Black Rock, six miles to the south-southeast. James again hailed his son, and together the surfmen and the volunteers headed for the Bayside Humane Society boathouse to collect the trusty surfboat *Nantasket*.

Joshua James, Hull's nationally renowned lifesaver, led the rescues of twenty men from four ships during the gale.

Already responding to the signal, Cohasset's Humane Society volunteers—Captain William Brennock, Albert Brennock, John Fratus, Allie Morris, Frank Martin, Joseph J. and Joseph E. Grassie, Manuel Antone and Frank Salvador—attempted to launch from Stoney Beach, only to have their boat capsize a few feet from shore. Struggling back up the beach, they headed for the summer home of George Swallow of the Governor's Council, where caretaker Arthur Mulvey tended to their needs.

Learning of the fate of the Cohasset volunteers, Captain James chose to launch instead from protected Gun Rock Cove, a mile to the north. After waiting an hour for the waves to diminish, the crew pushed *Nantasket* seaward and rowed quickly to the rock, the wind at their stern.

Bobbing with the waves, the lifesavers again paused to look for a lull before attempting to land their craft, waiting more than an hour. When the opportunity arose, they dashed for the island.

Once ashore, they headed for the only possible shelter, a small gunning hut. Inside huddled three cold and beaten men, the survivors from the *Lucy R. Nichols*. One man in particular showed contusions about his head and legs and complained feebly about what he thought was a broken shoulder. The lifesavers loaded the men into *Nantasket* and rowed for another hour headlong into the northwest wind. Once ashore at Gun Rock, James sent a messenger ahead to arrange for a doctor to meet the victims at the station. The lifesavers then began their six-mile journey back to Hull Village.

Returning to the Point Allerton station that evening, James instructed his men to stand down for the night and rest. Whoever could have been saved had been saved. Over the next few days, news describing the immensity of the storm and its path of destruction trickled into the station. More than 350 vessels had been damaged or destroyed between New Jersey and Nova Scotia, and approximately 500 people—192, by today's latest estimates, on the steamer *Portland* alone—had died. James and his men had saved 20. Mother Nature had won this battle against the storm warriors by unleashing the storm of the century.

Aftermath

The disaster scene left behind by the weekend's storm seemed surreal to the people of Hull. As far as the eye could roam, houses sat tilting on their foundations as if drunk, precariously close to toppling into streets or yards. Interwoven lengths of telephone, telegraph and electrical wiring mingled with five- and six-ton boulders along the outer shoreline of Nantasket and Stony Beaches. Sailing vessels, in various stages of destruction, sat confusedly on the tracks of the Nantasket Branch of the Old Colony Division of the New Haven Railroad. Just three years earlier, in the summer of 1895, the railroad had made the Nantasket run the first electrified line in the country. Now the 6.88 miles of track lay twisted and broken in many places, and the poles carrying their overhead lines were tossed along the wayside like matchsticks before the gale. Regular train service would not resume for months, stranding most of Hull's year-round population at the end of the peninsula.

On Tuesday morning, November 29, 1898, the *Boston Herald* reported the loss of the side-wheel steamship *Portland*, of the Boston-to-Portland run. Captain Hollis H. Blanchard, most likely figuring he could outrun the oncoming storm, had pulled away from Boston's India Wharf at precisely 7:00 p.m., on Saturday the twenty-sixth, a decision that proved to be fatal to the (at latest estimation) 192 crew members aboard. Twenty-four hours later, wreckage clearly identifiable as having belonged to the *Portland* washed ashore on Cape Cod. The weekend storm of November 26 and 27, 1898, will forever share her name: the Portland Gale.

From the cupola atop the Point Allerton U.S. Lifesaving Station, Keeper Joshua James and his tired surfmen held a commanding panoramic view of the devastation in Boston Harbor. Dozens of vessels rested eerily silent on the shores of Thompson's, Spectacle, Rainsford and Moon Islands in

The crew of the schooner *Albert Crandall* works to salvage whatever it can from the *Abel E. Babcock* in the aftermath of the storm. In the background, the *Calvin F. Baker*, run aground at Boston Light during the gale, sails past.

the inner harbor. The barge *Grant* had stranded on Gallop's, while the schooners *G.M. Hopkins, John S. Ames* and *Lizzie Dyas* had found final resting places on or near George's.

At the end of Great Brewster Spit, Narrows Light stood defiantly, proud to have survived the storm, like a heavyweight prizefighter who had walked away from a bout with John L. Sullivan under his own power, with every window gone and its icebreaker swept away. The three-masted schooner *Calvin F. Baker*, from which James and his men had saved five sailors from drowning or freezing to death the previous morning, sat high and dry out by Boston Light. The Massachusetts Humane Society mortar station on Little Brewster Island succumbed to the sea during the storm, taking both the station's Hunt gun and its dory, the *Benjamin Rich*, to the depths with it. (Construction workers building a new docking facility for the island found the gun six months later.) Lighthouse keeper Henry Pingree, who vainly attempted to reach the *Baker* with a line fired from a shotgun at the height of the storm, now tended to his ailing wife, who would die in just a few short weeks from the shock and horror of listening to the cries of the dying men aboard the schooner.

Six miles to the east of Boston Light, once the familiar anchorage of the *LV 54*, the Boston Lightship, choppy waves tauntingly called attention to the fact that the sea had pushed the vessel away from its post. Two days later, it would steam its way back into position from Scituate.

Aftermath

The Golden Mile of Nantasket Beach, from Atlantic Hill to the north, alternately glistened with the shine of eleven thousand tons of washed-up anthracite coal, the lost cargo of a half dozen coastal barges, and showed the dull face of piles and piles of wood that once represented hundreds of thousands of dollars' worth of hotel rooms, restaurants and boardwalks. Mixed in with the wood and coal could be found quarter boards bearing the names of ships whose fates had heretofore been undetermined: the *James H. Hoyt*, the *Minnie Stowe* and the *Baltimore*.

As part of his official duties the day after the storm ended, Joshua James filled out a long report of the events surrounding the twenty-sixth through the twenty-eighth of November, using all of the front and the entire back of the 8½-by-14-inch sheet. On top of that, the Life-Saving Service instructed him to "ascertain the damage done the shores of Hull and the average rise of the tides during the recent storm" (*Hull Beacon* December 10, 1898).

Although the storm had ended meteorologically, its effects continued to harass the tired keeper for days, forcing him to put in longer than usual hours at a time when his seventy-two-year-old body needed rest. Twelve corpses washed ashore in the first few days after the storm, and according to the *Revised Regulations of the United States Life-Saving Service*, the responsibility for identification of such victims of the sea belonged to the captain. Walking the lonely lane down to the town dead house,

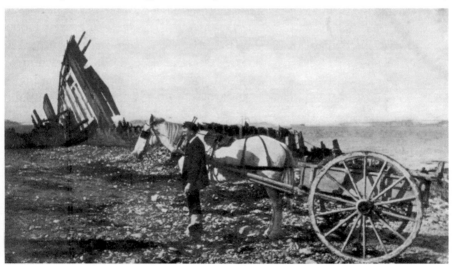

Coal—by the ton—was available to those folks willing to cart it off.

James did his best to match descriptive letters sent by mourning relatives to tattoos, scars and missing teeth.

Some bodies yielded very few clues. "Thursday morning the body of one of the shipwrecked sailors was picked up on Nantasket Beach in a perfectly nude condition with the exception of a belt about his waist. On one finger he had a silver ring. He was evidently a Swede about 30 years old." Others easily gave up their identities.

> *One of the bodies was that of a man 5 feet 9 inches in hight [sic], weighing about 175 pounds. His hair and mustache were sandy. On the inside of the right forearm, in india ink, there was a woman resting on a table, hand shading eyes, in left hand basket of fruit. The work is well executed. The woman is fancifully attired, the design being decidedly Parisian. Around the right wrist there is also a bracelet in india ink, connecting with a wreath on the inside of it, in which there is a woman's head.*
>
> *In one of the pockets the searchers found a letter addressed to "Mr. W. W. Phillips, 33 North 2nd St., Camden, N.J."*
>
> *The front of the envelope bears the following postmark, "Philadelphia, Penn., Nov. 4, 7.30 p.m., '98."*
>
> *On the back of the envelope is the reception postmark: "Camden, Nov. 5, 6 a.m., 1898, N.J."*
>
> *The letter is simply dated Friday, 1.30, and is addressed to "Dear Weston," which would correspond with one of the first initials on the envelope. The contents of the epistle is of a character that precludes any doubt that it belonged to any person than the one on which it was found. It bears only the signature of "Mattie." Persons bearing the following names are referred to in it: "Sophie," "Clara," "Will," "Mom," and "Mr. Kerns." (Hull Beacon 3 December 1898)*

Using such evidence, in some cases more and in some cases less, James identified four of the twelve bodies. The town buried the rest at Strangers Corner, a mass unmarked grave of nearly one hundred unknown sailors at the Hull Village Cemetery. The horrible, undignified manner in which shipwreck victims spent their final hours above ground in Hull—no caskets, no embalming—inspired local newspaper editor Floretta Vining to push for the appointment of a town undertaker and the construction of a receiving tomb, for storage of dead bodies until they could be positively identified.

As if wrestling with such a horrible chore were not enough to wear down his resolve, James also had to face the hopeful families of the crew

Aftermath

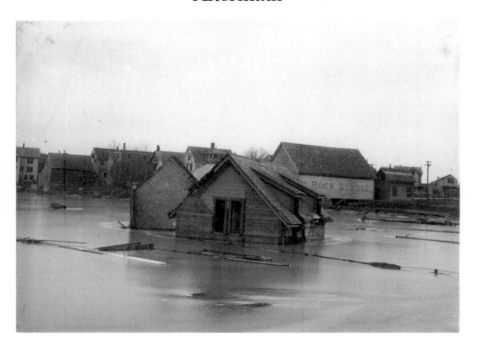

Cottages and other small buildings pushed from their foundations ended up in Straits Pond at the southern end of town.

of the schooner *Abel E. Babcock*, who had read in one of the Boston papers that the men of Hull had heroically pulled their loved ones to safety and had come to the Point Allerton station to collect them; he could only report that the bow of the vessel had been found and nothing else. Heartbroken, the now-grieving families left for home. Two days after the storm, James also learned that one of his lifelong friends and the man who led his first lifeboat rescue, Moses Binney Tower, had died at his home in Auburndale at age eighty-four. Overburdened with his duties, James never got the chance to say good-bye.

Accolades for their accomplished feats of lifesaving began to filter in to the men of the Point Allerton station, showing them and their wives that their efforts were truly appreciated. "The rescued sailors taken to the Point Allerton station, Stony beach are profuse in their expression of gratitude to Capt. James' wife for motherly kindness and administration to their needs. Mrs. James stays at the station, preparing with her own hands, with the assistance of Mrs. George F. Pope, the meals and looking after the comfort of the mariners in every way" (*Hull Beacon* December 3, 1898). David Porter

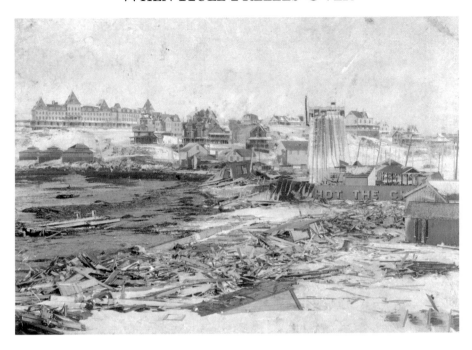

The destruction at Nantasket Beach seemed immeasurable. Although it stood through the storm, the Chutes was later torn down.

Mathews, James' nephew and managing editor of the *Hull Beacon*, went as far as to say, "Captain Joshua James and the other lifesavers of Hull should have a monument raised here to their memory" (December 10, 1898).

Probably the most surprising of the letters written to the attention of Joshua James came from the great pragmatist himself, philosopher William James of Cambridge, dated December 10, 1898: "Dear Sir: I am one of the many who were moved to admiration of the splendid behavior of your crew and volunteers during the recent storm. But what is the use of admiration in a 'dry' and academic shape? One ought to *do* something with it; and as I can't well go and save lives myself, I take the liberty of sending you a small check which you will best know how to place where it will do most good to those concerned, yourself included. I wish it were bigger! Believe me, with cordial regards to you all, truly yours, William James."

In the wake of the storm, David Porter Mathews editorialized about the need for one major change to be made for the improvement of the efficiency of the Point Allerton U.S. Lifesaving Station. On December 10, he wrote,

Aftermath

Without question there should be a lifeboat located on Windmill Point. Experience has demonstrated this over and over again. When unable to launch a boat on the outside of Stony Beach the lifesavers have repeatedly been compelled to row from the inside to Hull Gut and often through it in a head tide in order to rescue sailors on Boston Light and other islands, distances averaging from three to six miles, not in mild weather, but in boisterous seas and fierce head winds. This might be obviated by placing a boat near the Hotel Pemberton so that it could be readily launched in the hook or on the outside when the sea permitted.

It would take the federal government more than a decade to reach the same conclusion, but eventually the Coast Guard built a boathouse on Windmill Point.

On December 23, 1898, Mathews proposed a more ambitious plan to help ease the strain on the local lifesavers.

Standing on the promontory of Battery Heights and viewing the remains of the once noble schooner Abel E. Babcock wedged among the "Toddy Rocks," one cannot dispel the feeling of sadness that steals over him as he thinks of the total loss of her crew in the storm of Nov. 27; their sufferings in the bitter cold and the yielding to the inevitable fate which swept every soul on board into the raging sea—into eternity—without one parting word with their dear ones.

And their bodies, where are they? Swept away, it may be, beyond recovery.

Sad indeed is the requiem that comes up from the lonely rock-bound shore and the monotonous swash of the sea about the wreckage and among the fatal sunken bowlders [sic] only a few hundred yards away from terra firma and safety.

Why can't these terrible rocks be removed? Blown out of existence? The number of vessels lost upon them is almost inestimable.

Last winter not less than four large schooners went ashore on this reef, but fortunately without loss of life. This winter two vessels have been wrecked upon them, the schooner Abel E. Babcock and her entire crew lost, the Consolidated Coal Company's barge Number Four with the loss of three men. Alas! How many more in the future will be destroyed on this spot we dread to think.

One week after the storm, on Sunday, December 4, James and his crew responded to a horrible cry just outside of their building, dashing out into

49

the blackness of night with lanterns in hand, foraying through both the duck pond behind the station and the beach across the way. After an extended search, they concluded that either they had better prepare to look for a body at daylight or they had been given a false alarm. Neither case proved to be true. The "unearthly and blood-curdling" scream that they had heard actually came from a passing admirer on horseback, young James Cashman, who offered his salute to his heroes on his way by.

> *Now don't laugh at the life savers. This incident shows how prompt and faithful they are to respond to every cry. Since their fearful experience in the late storm the very atmosphere is haunted with distress cries.*
>
> *Cashman's voice, however, out rivals any Banshee's or megaphone ever known. It would make a good siren whistle or fog horn. So say the life savers. (*Hull Beacon *10 December 1898)*

With their nerves on edge, expecting an aftershock of the storm to hit at any moment, Joshua James and his men moved about their daily duties with extra caution. Matthew Hoar, the surfman who had been granted a transfer to Fourth Cliff station in Scituate, effective December 1, had to wait until the fifteenth, and then he arrived at the station to find that he would never have to make a northward patrol; the North River had blown away the barrier beach between Third and Fourth Cliffs during the gale, leaving the

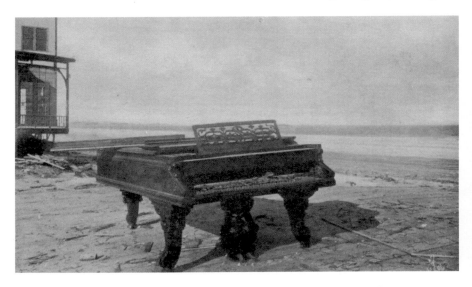

Although the hotel surrounding it was blown away, this piano stood its ground.

Aftermath

Humarock section an island unto itself, with the Fourth Cliff station now sitting at the northern end.

Although they realized that the storm they had just endured would probably be the worst natural disaster they would ever see in their lives, James and his men knew that in referring to the trials of living along the coast, no truer words could be spoken than those uttered by Captain H.S. Cobb of the schooner *Henry R. Tilton* as he gazed upon his stranded vessel on the beach: "We are saved now but will probably have to go through the same thing again." After the disappearance, destruction or stranding of more than 350 vessels between New Jersey and Nova Scotia and the loss of more than 500 lives, the carnage of the Portland Gale soon came to an end, and the lifesavers could stand down.

Until the next storm.

A tomb for receiving the dead

As the people of Hull emerged from their homes in the days following the Portland Gale, they assessed the damage done by the latest nor'easter to tear through their town. They found uprooted trees everywhere, including poet John Boyle O'Reilly's famed cherry tree. Tangled masses of wires blocked the streets, caught up in ten-foot snowdrifts. Huge boulders and all manner of flotsam and jetsam lay on the railroad tracks along Stony Beach, disrupting any and all service.

Between Green and Center Hills, sixty cottages had been wrecked. Some had been knocked off their foundations, while others had been blown to pieces.

Yet the most disturbing of all the results of the Portland Gale had to be the unnerving number of bodies that washed ashore each day at different parts of the beach. Snow could be cleared away and houses could be rebuilt, but no one wanted to take on the unenviable task of identifying and burying more than a dozen dead sailors.

Hull's year-round population in 1895, according to the state census, totaled 1,044 citizens. Ten years prior to that count, Hull had a population of 451. It had always been known as one of the smallest towns in the state, and therefore its inhabitants had never before really had to deal with the death of its own residents on a grand scale.

But occasional maritime disasters left piles of dead on shore. On November 3, 1861, the ship *Maritana* went to pieces on Shag Rocks, east of Boston Light, and twenty-eight people perished before Samuel James could save them. He managed to rescue the last thirteen.

Smaller tragedies also occurred through the years. Hull's beautiful position along the coast always brought with it the terrible responsibility of caring for the dead tossed ashore by the relentless, unforgiving sea. In the final

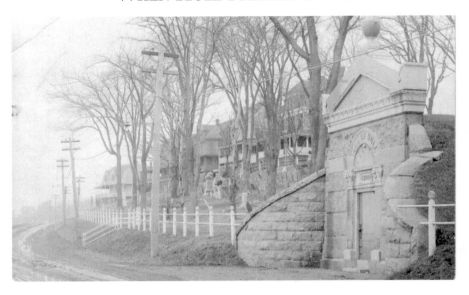

As a consequence of the Portland Gale, the Town of Hull built its receiving tomb.

four decades of the nineteenth century, an estimated one hundred mariners found their final resting place in the Hull Cemetery, "known only to God," according to the etching in the stone that now stands over Strangers Corner.

The storm of 1898 and the destructive heavy snowstorm of the following February impeded the speedy burial of the sea's unknown dead. Not only was the ground in the graveyard frozen solid, but it was covered in many spots with six to ten feet of snow. Men with shovels could do only so much digging.

Up until that time, all dead bodies in Hull were prepared for burial in the dead house, a small wooden shack at the end of a usually dusty road. Dead townspeople had never waited long to be buried. According to James Allen's diary of 1862, Mrs. Sophia Cobb gave birth to twins on August 11 and died that night. She was in the ground by the afternoon of the thirteenth, about thirty-six hours later.

But town officials delayed burying strangers as long as possible, hoping they would be identified and claimed by loved ones. In some cases, loved ones arrived too late, but the keepers of Hull's city of the dead would exhume bodies if so requested.

In July 1899, eight months after her seventeen-year-old nephew Chester A. Daniels of the schooner *Leander V. Beebe* disappeared, Kate McLean of Malden made the trip to Hull to claim his body. The first exhumation in

A tomb for receiving the dead

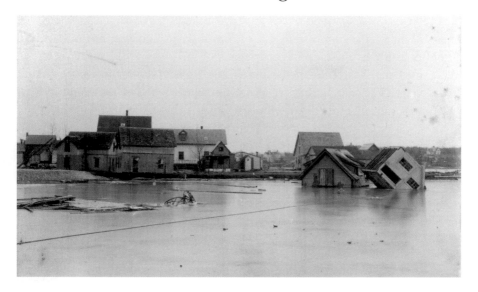

Storms powerful enough to throw houses around usually took lives. It was at times like this, after the storm of the century, when a proper receiving tomb was called for.

the spring had proven inconclusive, so this time she brought along one of young Daniels' friends, who recognized him immediately, but only from his clothing. They placed Daniels' body in a metallic coffin and transferred it to a final, final resting place in Malden.

Floretta Vining, business editor of the Vining and Mathews Syndicate of South Shore Newspapers, watched with dread as the dead bodies made their way down that long road to the dead house in December 1898. She thought it absurd that a moneyed town like Hull had such inadequate facilities, so disrespectful to the dead. So she made some noise.

Vining called for the elected town officials to OK the construction of a "receiving tomb" at the base of the cemetery. She gave three main reasons that it was needed when she presented her argument before the town meeting in March 1900. First, when snow covered the ground, a sealed tomb would provide ample storage for bodies until the earth thawed enough for burial. Second, a tomb would allow more time for relatives of deceased strangers to identify and claim their loved ones. And third, a receiving tomb would do wonders to ease the Victorian fear of premature burial.

In the late 1800s, the possibility of being buried alive was very real. Today, with all of our modern medical technology, doctors know definitively whether or not a person is alive. In 1898, the line was not as clear. Cases

existed where a person entered a catatonic state and was entombed and forgotten, only to wake up in the grave.

In southern New England in the 1790s, mostly along the Connecticut–Rhode Island border, a number of vampire stories can be accounted for by premature burial. The "dead" would wake up and start clawing at the inside of their caskets, trying to get out, before they slowly died of asphyxiation.

When a body was dug up, either because of inexplicable noises or the suspicions of townspeople who believed that certain families had histories of vampirism (most likely family members all stricken with the same communicable disease and prematurely buried), the corpse might be shifted from its original burial position, fingernails and hair would be longer and the interior of the casket would be torn from the "deceased's" frantic scratching.

At first, New Englanders believed these people to be vampires and reburied them with stakes through their hearts, just to be safe. Then, as common sense prevailed, people began to realize they had been burying their loved ones alive. Then came the even more alarming realization that they could be next.

As early as 1868, an inventor had patented a new type of casket that would allow one last chance at escape for the not-quite-dead. The coffin included a small tower that poked out of the ground above the head of the deceased. Inside the tower there was a ladder, and, if you were strong enough when you awoke, you were supposed to climb up the ladder and out of the afterlife to safety. If you were not strong enough, you simply pulled on the string tied to your finger, which would ring a small bell above the ground. The townspeople would hear the bell and come running with picks and shovels—and hopefully without stakes—to welcome you back to the land of the living.

The second major change that the fear of premature burial fostered concerned the amount of time taken between the declaration of death and interment. Victorians felt a lot better about giving the deceased a few days to wake up, instead of performing same-day or next-day funerals. And so today, we have the *wake*.

The old fears did not die easily. One Hullonian today remembers her grandmother's instructions to prick her arm with a pin before the casket closed, just in case.

And so the townsfolk voted in 1900 to allocate thirty-five hundred dollars toward the construction of a receiving tomb. Although the project got off to an uneasy start—contracted builders John R. Richards and

A tomb for receiving the dead

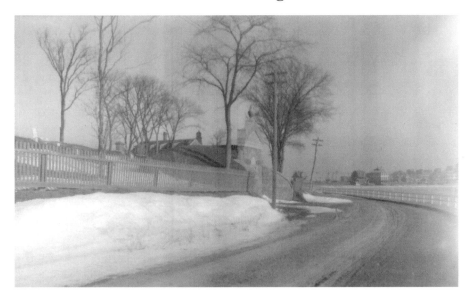

The receiving tomb changed the face of Spring Street forever.

Stephen Bianchi miscalculated and accidentally unearthed the bones of long-dead Mary Gould—the end result was the structure that still stands at the cemetery today.

At that same town meeting, the town appointed its first official burial agent, J. Walter Pyne of Emerald Street in Hingham (forebear of Pyne-Keohane Funeral Home).

Yes, the town meeting made great strides in the care of the dead that day. Rather than shirk the responsibilities that came with living in an oceanside resort town, Hullonians decided to make sure that loved ones of those sailors lost on our coast would have a chance to say good-bye and that those people still alive when pronounced dead would have a chance to prove it.

The strange tale of the *Glendower*

On February 12 and 13, 1899, the residents of Hull endured one of the heaviest and deepest snowfalls ever remembered at the end of the peninsula. For the second time in three months, snow had rendered Hull's roads and railroads impassable, blocked by snowdrifts that climbed to twelve feet in height. The Stony Beach railroad station, destroyed during the Portland Gale of November 26–27, 1898 and subsequently rebuilt, collapsed again under nature's wrath. The inner harbor froze completely, and high tides carried in ice floes that chopped away at the town's piers, eventually dragging several landings away to sea. A wall of ice ten feet thick stretched the entire length of Nantasket Beach.

On the afternoon of Sunday the twelfth, the captain of the tugboat pulling the coal-carrying schooner-barge *Glendower* through Nantasket Roads watched warily as the ice around the barge thickened to the point that it became unable to move, even with the tug at full throttle. Not at all desirous of having the same fate befall his vessel, the tug captain cut the line adjoining the two craft and headed for shelter in the inner harbor, signaling for the captain of the *Glendower* to drop anchor and ride out the building snowstorm where the barge was.

But the northeast wind proved too powerful for the barge to stand against, and it drifted to the southwest, finally stranding on Toddy Rocks at the northern base of Souther's Hill. The crew of the Point Allerton U.S. Lifesaving Station had watched the *Glendower* from their cupola all day long and immediately responded to the predicament by dragging a lifeboat across the ice to the barge. Boarding the vessel, the lifesavers offered to transport the stranded crew to safety.

The four-man contingent aboard the *Glendower* then made a decision that would nearly cost them their lives. Trusting that the captain of the tug

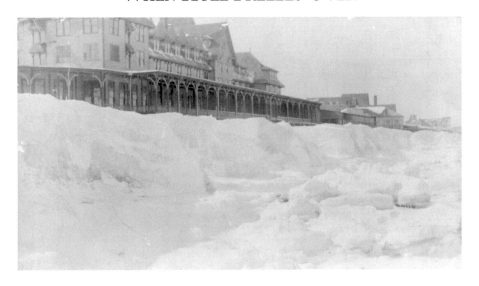

Two months after the Portland Gale, a powerful snowstorm struck Hull once again, stranding the schooner-barge *Glendower*. This ice wall appeared in front of the Hotel Nantasket in February 1904.

would return the next day, they opted to stay aboard, confident their barge would be floated to safety at the next high tide.

When it became obvious to Captain Joshua James that the tug would not be returning on the morning of Monday the thirteenth, he and his crew returned to the barge and advised the stranded sailors to come ashore. Wanting to safeguard the 1,300 tons of coal on board, though, the crewmen again chose to remain aboard their vessel. Before leaving, the lifesavers ran a line from the *Glendower* to the shore, providing the crew with a safe escape route, and instructed them on how to pull themselves to dry land. The surfmen also told the sailors that they would return to help if needed.

Later that morning, unbeknownst to the lifesavers, the barge sprung a leak. In a panic, the crew of the *Glendower* blew a whistle to alert the men of Point Allerton and lowered the barge's yawl into the icy water below. As a blinding northeast snowstorm whirled up, the sailors attempted to pull themselves to shore using the line provided by the surfmen, but before they reached their destination the line snapped and the hapless crew drifted to sea among the ice floes as Hull townsfolk watched helplessly from the beach.

As this drama unfolded at Toddy Rocks, the lifesavers set themselves to engaging horses to haul the beach apparatus (breeches buoy and line-throwing gun) to the scene. Unable to see anyone aboard, the surfmen

The strange tale of the *Glendower*

fired a shot from the Lyle gun across the barge but received no response.
(The report of the *Hull Beacon*, dated February 18, 1899, claims that the
lifesavers dragged their boat across to the barge, while the official report
of the *Annual Report of the United States Life-Saving Service, 1899*, taken from
Keeper James' daily report, gives the above scenario.) Within moments, a
lone man walking along the beach hailed Joshua James and informed him
of what had transpired with the yawl. The captain gathered his men and
returned to the station.

James immediately telephoned both the Boston Harbor police and the
T Wharf tugboat company, who informed him that a tug now at
Pemberton landing should be able to help search the harbor. The keeper
sent a messenger to Pemberton, but the tug could not be found.

With snow swirling around them, the four crewmen aboard the yawl
drifted aimlessly toward Quincy Bay until about midnight, when the tide
carried them back out past Peddock's Island and into Nantasket Roads.

At daybreak on the morning of Tuesday the fourteenth, the captain of
the tug *Juno* spotted the helpless quartet floating dangerously toward the
heavy breakers on the Point Allerton Bar. Forcing his craft through the ice,
he finally collected the four men, who amazingly, after eighteen hours of
exposure to one of the worst snowstorms recorded in Hull history to that
point, sprightly leapt from their yawl to safety.

The drama of the *Glendower*'s unusual run of bad luck in Hull continued.
Wreckers succeeded in removing the barge's cargo but were unable to refloat
her right away. On the night of March 21, a surfman on patrol passing the
Glendower noticed a fire on board and roused the rest of the crew. Hauling
buckets of water aboard, they subdued the flames and saved twenty-five
thousand dollars' worth of pumping machinery. Badly damaged, the
Glendower nevertheless would float again.

Twelve years later, the ill-fated barge again made headlines in Boston
Harbor. At about eight in the evening on June 9, 1911, the captain of the
tug *Monocacy*, pulling the *Bast*, *Glendower* and *Rutherford*, received word that
there was trouble aboard the middle barge. The *Glendower*'s captain, Charles
Wyman, was dead.

The captain of the tug ordered all of the barges into Boston under their
own power, disconnecting their lines. Boarding the *Glendower*, expecting to
find Captain Wyman dead of natural causes, the tug captain was stunned
to walk into an obvious murder scene. Wyman, facedown in his bunk, was
a bloody, mangled mess. The tug captain called the Boston police, who
arrested the three remaining crewmen as the medical examiner counted a

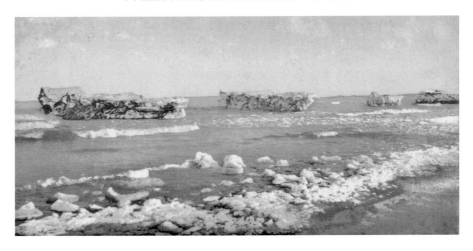

Ice can form on Hingham Bay in the winter. These "baby bergs" drifted ashore at Kenberma in February 1898.

total of twenty-seven axe wounds on the corpse. No axe could be found on board, though, and no crewman showed blood stains on his clothing.

After questioning the three men, Suffolk County district attorney Asa French concluded that William De Graff, a hunchbacked Dutch cook, had murdered his captain. Both Antonio Priskich and Bill Nilsen, the other crewmen, claimed to be above decks for most of the afternoon, the former having relieved the latter at the wheel at two o'clock, the approximate time of the murder. Nilsen claimed to have heard the captain yell out gruffly from below, "Get out of here!" at about that time. De Graff, conversely, had spent the afternoon in his room, sixteen feet from Captain Wyman's door.

Fittingly, the *Glendower* murder trial took place during a February blizzard in 1912. The prosecution could muster nothing stronger against De Graff than a fellow barge sailor who claimed to have heard the deformed cook utter, "Captain Wyman is no good." After deliberation the jury found De Graff not guilty for want of evidence. Two years later, Philadelphia seaman John Breen revealed this startling testimony, under deposition: "De Graff had specifically gone to Newburyport from Philadelphia to join the *Glendower* crew as a cook, for the sole purpose of murdering Captain Wyman" (Robert Ellis Cahill, *Haunted Ships of the North Atlantic*, 9). Twenty years previously, Wyman had flogged young De Graff aboard a Maine schooner, knocking him out of the rigging and

onto the deck, crippling him for life. The captain never recognized his would-be killer as the young sailor he had whipped into disfigurement.

The *Glendower* never went to sea again. Some believe that it simply rotted at dockside in Boston, but Robert Ellis Cahill, author and founder of the New England Pirate Museum in Salem, feels he has found a more fitting end for the seemingly cursed barge. At Miller's Wharf in Salem there sits an abandoned building, the second story of which is composed of an old barge. The first time he entered the second story of the building, formerly the summer home of Captain Herbert Miller but presently the property of a friend of Cahill's who planned to turn it into a restaurant, a voice out of the darkness startled the writer, shouting at him, "Get out of here!" After running down the steps, Cahill told his friend his building was haunted.

In a letter from Cahill to this writer dated March 28, 1998, Cahill states: "Your research on the old barge is great, and yes, it must be the same barge on which the murder was performed, and where, I believe, the ghost of the captain haunts the second floor of the shack at Miller's Wharf. This, of course, is speculation on my part, but all the pieces seem to fit. It sounds like the *Glendower* was kind of a hoodoo vessel."

Does it ever.

A turn-of-the-century Christmas

On Thanksgiving Day, 1896, the Hull town football team defeated rival Hingham by a score of 10–0, but Hingham complained that Hull had cheated by loading its team with college players. On Thanksgiving Day, 1897, Hingham defeated Hull 4–0, but Hull claimed that it had been given unfair field position, forced to play the entire game uphill. The Portland Gale has wiped out all memory of the Thanksgiving Day, 1898, game.

On Thanksgiving Day, 1899, Hull team members stayed home and played against their kids. The fathers, known as the Gladiators, accepted the challenge of their sons, who called themselves the Boers (after the South African settlers of Dutch extraction then fighting the British), and met them on the green grass of the Village Park behind the town hall. On that afternoon, the kids of Hull got a chance to see what age, experience and wisdom can do, for "the Gladiators, who should have been called Johnny Bulls, whipped the Boers with a score of 12 to 0" (*Hull Beacon* December 8, 1899).

The weather that holiday afternoon had been perfect for football and for any other outdoor activity, for that matter. Although many residents of the town held deep apprehensions about the coming winter season, remembering all too vividly the previous November's storm (Osceola James, the head of the volunteer lifesaving crew in Hull, in particular had spent countless hours preparing the Humane Society's boats and equipment for what he believed would be inevitable storms and life-threatening disasters), the weather remained mild on into the month of December.

Temperatures remained pleasant enough for work to continue atop Telegraph Hill, where soon operator Simon Peter Lucihe would send his dispatches telling of ships passing in and out of port to the city of Boston from a new Western Union telegraph tower.

When Hull Freezes Over

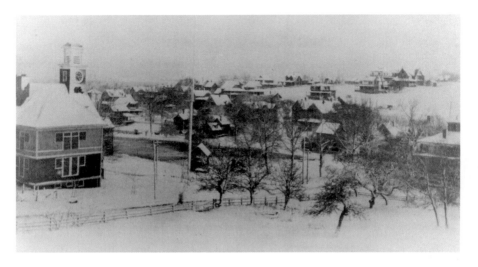

Hull Village held a serenity all its own when blanketed with snow.

Although progress seemed slow to the casual observer during the early days of December, the *Hull Beacon* reported on the twenty-ninth that Lucihe was "occupying his new quarters in the Western Union station on Gallop's hill. The old edifice, which faced the wintry blasts of half a century, has been demolished. The old building during all these years was a landmark for seamen."

Other projects continued late into the season as well. On Lovell's Island, where the federal government had begun preparations for the construction of Fort Standish, James F. Dowd, a hardworking Hull expressman keeping busy during the off-season, attempted to solve his logistics problems. Contracted to feed the men working on the site, he relied on tugboats passing the islands to transfer stores into his stock when the regular Fort Warren steamer could not be counted upon. For quick and easy access to fresh milk, he smartly brought over a cow.

At the other end of the Hull peninsula, real estate transactions continued to move at their normal breathtaking pace. Although the rumor of a hotel being built at Kenberma proved false, reporter David Porter Mathews of the *Hull Beacon* broke the story on the fifteenth that "Mr. Durgin of the Quincy Savings Bank has recently become the owner of Sagamore Hill, having purchased it of Mr. J.F. Merrill."

While Police Chief John L. Mitchell and Surfside Postmaster Frank M. Reynolds headed for the Maine woods for a few weeks of deer and bear

A turn-of-the-century Christmas

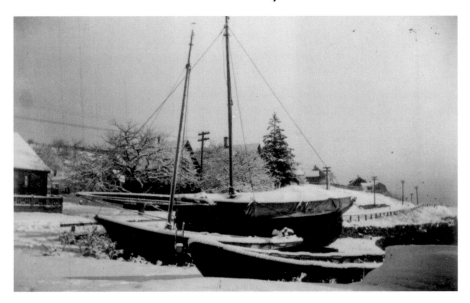

If the weather allowed them to do so, Hull's many mariners found work and play on the bay and ocean with their boats well into the colder months.

hunting, John W. James and his brother, Samuel Jr., headed out on a hunt of their own. In early November, they "secured a small steamer" in which they intended to "sweep for lost anchors. She now lies puffing and blowing, sneezing and wheezing off their pier. It breaks up the monotony of the season" (*Hull Beacon* November 10, 1899).

And, if the hunt went successfully, it also broke up the monotony of an empty wallet, as raised anchors could be sold for their metal. By the first of December, the James boys had hauled in eight anchors. Seeing gold in the rusted iron lifted from the sea by their cousins, Francis and Reinier James Jr. set out to try their luck. The following week, Harrison Mitchell became a Hull anchor-dragging legend when the *Beacon* reported on the eighth that he had "found an anchor he has been unable to start from its lodgement in the mud. A diver who went down reports it to be a big one."

The less hardy types in town who enjoyed indoor activities attended the whist parties that flourished in the village in the weeks leading up to Christmas Day, 1899. Some clubs, like the Fudge Whist Club, met just for the company and fun and games, while one group in particular, the Dignitaries, found that the game itself could use some spicing up. Members started out by wearing uniforms of a sort—"short skirts and white shirt waists with black ribbon across the breast"—but soon moved to more advanced costuming,

including Cyrano de Bergerac noses, white caps, kerchiefs and aprons. At the end of each evening, the host of the coming week's party designated what the fashion would be. By the end of the winter, the club had dressed as if members were upside down (shoes on hands, pants over head, etc.), as fairy tale characters and as representatives of different nations.

Yet not all of Hull's inhabitants could so enjoy the absence of bad weather like the anchor draggers, football players and Dignitaries. Charles Howard Smith, one of Hull's leading real estate men, returned to work on Monday the fourth from his birthplace of Barnstable, where he tried to shake off his illness and unexplained (to his family and friends, anyway) melancholia.

Mrs. Hannah Smith made her first appearance back home in a year after recuperating from a severe shock to her nervous system caused by the explosion of an oil can in her home during the winter of 1898.

Harold West, the shopkeeper at West's Corner who routinely carted his goods into the village every Monday, suffered severe injuries when a steam boiler he was attempting to repair blew up in his face, opening up a wound and burning him badly.

At the Point Allerton U.S. Lifesaving Station, Joshua James and his men graciously accepted the fact that they had done little actual lifesaving during the 1899 calendar year, for the last two months of 1898 had nearly killed them all. In February of 1899, they tended to the wreck of the schooner-barge *Glendower* on Toddy Rocks, eventually saving the crew after a harrowing series of events.

Believing that the boat would refloat itself with the tide, the crew opted to stay aboard, even during a howling snowstorm. When the vessel began to break up, the sailors boarded a life raft but soon found themselves drifting out to sea. A tugboat returning to the harbor towed them back inside Point Allerton, where James and his men collected them and brought them to the station for warmth and food.

Six days later, the lifesavers offered succor to three wreckers working on the stranded schooner *Henry R. Tilton*. They responded to one alarm in July, two in September and one in October, and fired a Coston signal flare in December to warn a schooner away from danger. Otherwise, they drilled and prepared, as they normally would have.

Sadly, Joshua James said good-bye to two of his lifelong friends that season. He acted as pallbearer for both Lewis P. Loring and John Reed. Loring, who passed away in late October, drew high praise from *Beacon* editor Mathews on December 1: "We sincerely hope that a picture of Lewis P. Loring will be

A turn-of-the-century Christmas

placed in the town hall. It belongs there, for no citizen has ever stood more valiantly for clean government and purity in town affairs."

Reed, James' senior by four years, died the week before Christmas. A Republican for most of his life, he switched over to the Prohibition Party in 1895. His lifestyle led him to resign from the board of selectmen due to his refusal to sign liquor licenses. He would be remembered by all as the man who first allowed the Catholics in Hull to use the town hall for their masses.

As the holiday approached, James watched as more familiar faces moved on and other, foreign countenances took their places. Surfman James Curran of Scituate, a patrolman who had been serving at Point Allerton for three years, transferred to the Fourth Cliff station to be closer to home in early December. Back in September he had dislocated his elbow riding his bike to Scituate on his day off and did not like the idea of being so far from familiar surroundings. Hulver M. Gillerson, of the City Point floating station, relieved him. William Gray of Gloucester came on as the winter man later in the month.

On Friday morning, December 22, tragedy struck again. While crossing Hull Gut, a small boat laden with junk purchased on Peddock's Island overturned, dumping its contents and all three of its occupants into the swiftly moving incoming currents. One man, Thomas Olsen, grabbed onto the boat and clung for dear life as it headed for Bumpkin Island.

Seeing his plight, George Lowe and Thomas Cragin intercepted him and brought him aboard the schooner *George S. Boutwell*, where they resuscitated him out of his unconscious condition. The other two men, Henry Jinsberg and Maurice Labwitch, both residents of Quincy, never resurfaced.

Joshua James and his surfmen launched a boat and searched Quincy Bay, surmising that the tide may have sent the men as far as Crow Point in Hingham, but they found no trace of them. When the tide turned, the men could easily have been swept out to Minot's Ledge or beyond, sure to be lost forever.

Christmas Eve arrived as a storm blew through the streets of the village. The temperature dipped below the freezing level, although there would be a green Christmas, and the locals flooded the Village Park in order to allow children to practice their ice-skating techniques.

The young men of the town organized a last-minute ball at the town hall, which drew out quite a crowd, collecting $18.50 in receipts for admission. Satisfied with the fun of it all, as they closed the door to the hall, they decided to do it all again on New Year's Eve.

When Hull Freezes Over

As the sun rose on Christmas Day, the children of Hull either played indoors, with their new dolls and toy trains, or went outdoors, skating at the park or wishing there was at least enough snow with which to build snowmen. Older siblings, parents and grandparents stoked fires, cooked Christmas meals and reflected on the year's events. The widow of Henry Jinsberg walked from door to door in the village, pleading for help in finding her husband.

Soon enough, as the sun went down and Christmastide 1899 passed into eternity, the people of Hull increasingly embraced the only exciting fact that could outdo the magic of the holiday just passed.

All the amazing inventions that the nineteenth century had wrought—the sewing machine, the telegraph, the telephone, the horseless carriage—would pale in comparison to what was to come. Just one short week away lay the dawn of a new era: the year 1900, the beginning of the twentieth century.

A bold,
brave new world

As the turn of the century approached, the thousand or so year-round residents of the town of Hull reflected upon the changes that had taken place in their town over the past one hundred years.

First, they realized that the population in their community had actually increased tenfold since 1800. Many of the families that left the town during the American Revolution had never returned, dropping the population from a high of about 250 to approximately 125 hardy souls. The population remained at about that level until around 1825, when it slowly began to rise.

The year 1826 had marked the birth of a new era. The construction of Paul B. Worrick's Sportsman, later to be known as the Worrick Mansion, became the town's first seasonal hotel, drawing personalities as eminent as Ralph Waldo Emerson and Daniel Webster for short stays in coming years. Other hotels followed, including the Rockland House in 1854, which would at one time become the largest hotel in the United States, the Atlantic House and the Hotels Pemberton and Nantasket, among others.

The nineteenth century also brought trains and steamboats to Hull, creating an ease of access to the peninsula that Boston residents had never had before. At first the trains moved only between the steamboat wharves at Nantasket and Pemberton and did not connect to the outside world for passenger service. By the end of the century, the New York, New Haven and Hartford Railroad would test the first American overhead electric line in Hull, knowing it would at least make its money back, judging from the unseemly amounts of money being spent at the community's hotels, restaurants and other amusements. And the nineteenth century brought the town's main thoroughfare, Nantasket Avenue, yet another means of accessing the far reaches of the peninsula from beyond the town's borders.

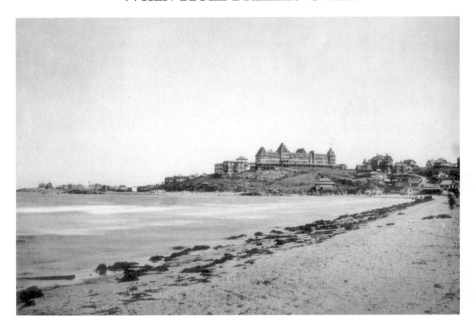

The opening of the Atlantic House was one of the hallmark moments of the nineteenth century.

By 1900, Hull had become home to some of the world's most famous lifesavers, a playground of the rich and famous, thanks partially to the founding of the Hull Yacht Club in the 1880s, and an unparalleled summer resort for the region.

Things had gone right for the community in the 1800s. As Hull residents looked into the 1900s, they could only wonder, with the rest of America, what the future would bring.

"Grand opera will be telephoned to private homes, and will sound as harmonious as though enjoyed from a theatre box," stated John Elfreth Watkins Jr. in the December 1900 *Ladies' Home Journal* in his article "What May Happen in the Next Hundred Years." Perhaps he got the wires crossed, but he did forecast the invention of radio with that one sentence, a couple of decades ahead of its time.

He continued:

> *Automobiles will have been substituted for every horse vehicle now known. There will be, as already exists to-day, automobile hearses, automobile police patrols, automobile ambulances, automobile street sweepers. The*

A bold, brave new world

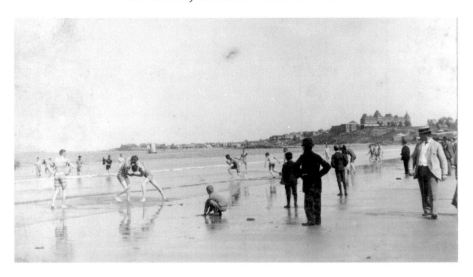

During the nineteenth century, Nantasket Beach had transformed from a long, barren, empty plain to a crowded summer resort.

horse in harness will be as scarce, if, indeed, not even scarcer, than as the yoked ox is to-day...There will be air-ships. They will be maintained as deadly war vessels by all military nations. Some will transport men and goods. Others will be used by scientists making observations at great heights above the earth.

Photographs will be telegraphed from any distance. If there be a battle in China a hundred years hence snapshots of its most striking events will be published in the newspapers an hour later. Photographs will reproduce all of Nature's colors.

In effect, Elisha Gray invented the world's first fax machine in the 1800s. "Extraordinary progress has been made in systems of telegraphy, some of the new inventions being capable of remarkable feats in the rapid sending of messages, while it is possible now to transmit pictures as well as words over the telegraphic wire" (Charles Morris, LL.D., *Famous Men and Great Events of the Nineteenth Century*, 546).

"A husband in the middle of the Atlantic will be able to converse with his wife sitting in her boudoir in Chicago," continued Watkins. "We will be able to telephone to China quite readily as we now talk from New York to Brooklyn. By an automatic signal they will connect with any circuit in their locality without the intervention of a 'hello girl.'

"Hot or cold air will be turned on from spigots to regulate the temperature of a house as we now turn on hot or cold water from spigots to regulate the temperature of the bath...Rising early to build the furnace fire will be a task of the olden times." Steam heat already existed for the rich, but the implementation of a system of climate control at the push of a button, or air-conditioning, had yet to be perfected.

Yet, as we know from the laws of intellectual physics, for every prediction, there is an equal and opposite rebuttal. "The ordinary 'horseless carriage' is at present a luxury for the wealthy; and altho [*sic*; see below] its price will probably fall in the future, it will never, of course, come into common use as the bicycle" (*Literary Digest* October 14, 1899). The *Digest* should have learned to never underestimate the laziness of the human spirit.

> *The example of the bird does not prove that man can fly...There are many problems which have fascinated mankind since civilization began, which we have made little or no advance in solving...May not our mechanicians...be ultimately forced to admit that aerial flight is one of that great class of problems with which man can never cope, and give up all attempts to grapple with it?...Imagine the proud possessor of the aeroplane darting through the air at a speed of several hundred feet per second! It is the speed alone that sustains him. How is he ever going to stop? (Simon Newcomb, head of the Nautical Almanac Office of the United States Naval Observatory at Washington, in* The Independent, *22 October 1903, quoted in Mark Sullivan's* Our Times, *Volume 1, 366)*

Less than two months later, on December 17, 1903, Orville and Wilbur Wright, assisted by surfmen from the Kill Devil Hills U.S. Lifesaving Station, launched their flying machine into history.

But what of the predictions that never did come true? What hare-brained (or so perceived today) schemes did our ancestors concoct that never got past the drawing board?

According to John Elfreth Watkins's article "What May Happen in the Next Hundred Years" in the December 1900 *Ladies' Home Journal*, "There will be no C, X, or Q in our every-day alphabet. They will be abandoned because unnecessary. Spelling by sound will have been adopted, first by the newspapers." Hence the 1899 spelling of *altho* above. "Everybody will walk ten miles. Gymnastics will begin in the nursery, where toys and games will be designed to strengthen the muscles...A man or woman unable to walk

A bold, brave new world

Automobiles—here a Winton touring car is exhibited by Scituate's Walter Sargent—would become synonymous with progress at the beginning of the twentieth century. *Courtesy of the Scituate Historical Society.*

ten miles at a stretch will be regarded as a weakling. A university education will be free to every man and woman."

Whereas today we see computers and the incredible intercommunication network they have created as the ultimate in convenience—what with e-mail, instant messaging, product ordering and even online grocery shopping— our forebears, as Watkins continues, saw a system of pneumatic tubes as the solution to all of the world's problems.

> *Ready-cooked meals will be bought from establishments similar to our bakeries of to-day…Food will be served hot or cold to private houses in pneumatic tubes or automobile wagons. The meal being over, the dishes used will be packed and returned to the cooking establishments where they will be washed. Such wholesale cookery will be done in electric laboratories rather than in kitchens. These laboratories will be equipped with electric stoves, and all sorts of electric devices, such as coffee-grinders, egg-beaters, stirrers, shakers, parers, meat-choppers, meat-saws, potato-mashers, lemon-squeezers, dish-washers, dish-dryers and the like. All such utensils will be washed in chemicals fatal to disease microbes. Having one's own cook and purchasing one's own food will be an extravagance.*

One can almost visualize the Bugs Bunny–style assembly line moving along, robots at each station doling out portions of different foods until the plate slides to the point where a metallic arm reaches down and tucks a bit of garnish on the side, and voilà! Zee automated meal, she is done. And then—*shoomp!*—from the laboratory to your kitchen table.

Even John Douglas King, chief inspector of the New York Post Office in 1900, saw potential in pneumatic tubes. "He predicts that letter postage will be reduced to one cent per half ounce, that letters will be shot directly from the post office to business houses, hotels, etc., by the pneumatic tube system" (Morris, 659). Such a system would, of course, eliminate the need for mailmen, if all went according to plan. Other than the money saved by the purchase of one less Christmas card per year, this writer can see no advantages in such an extermination.

The fixation with pneumatic tubes came from a half century of testing such ideas. Josiah Latimer Clark, an Electric Telegraph Company engineer, proposed a system of underground tubes that would run between the London Stock Exchange and the Central Telegraph Office as early as 1853. A six-horsepower steam engine at the office would create a partial vacuum in front of the canister carrying the message

While the postmaster general dreamed of the day when underground pneumatic tubes would shoot mail from place to place, James Davis Bates still had to run his route by horse-drawn carriage.

A bold, brave new world

and literally suck it through the tube to its destination. Of course the day came when a carrier got stuck in the tube and the pressure from the vacuum caused the engine to implode, blowing out a wall at the office. Engineers turned to pushing carriers through the tubes instead with bursts of air, but an increasing number of blockages that could be cleared only by digging up the streets and opening the tubes caused scientists to look elsewhere for a better communications network (Tom Standage, *The Victorian Internet*, 95–99). In any event, the idea of "sitting in front of the tube" certainly had a different connotation in 1900 than it does today.

The Victorians held firm beliefs that the power of the mind would someday be fully released and put to use in a number of different ways. A Professor Quackenbos of Columbia University promoted hypnotic suggestion as a future cure-all. "I believe that as an agent of physical cure it will shortly come to be universally employed by trained nurses to carry their patients through the crises of disease. It will be used by physicians for intra-uterine inspiration, the character of the forming child will be determined by ante-natal suggestion, and this method of improving ethically and intellectually a coming generation will be practiced on so large and broad a scale that society will feel the uplift." He ended his remarks with an oft-repeated mantra, still prevalent today: "We are as yet only on the threshold of psychological discovery" (Morris, 662–63).

One man, Richard le Galliene, predicted that authors would someday shake off the shackles of the typewriter and the pen and directly mind-link with their readers. "It seems not unlikely that with the advance of science some more direct medium between the mind of the writer and the mind of the reader may be invented by some Edison of the future; some marvelously delicate instrument, not impossible to imagine, by which, on the one hand, the writer could record his thought without the medium of words at all, and by which, on the other, the reader could receive them equally without words or print" (Morris, 661).

Of course, not everyone forecast a brave, bold, shiny new world for the twentieth century. Eugene Markov, a Russian writer, apparently saw danger in the same trends that would later send Floretta Vining screaming into the night, hands thrown in the air. "One fears for the future of mankind. The most ominous sign is not the fact that the cook, servant-girl, and lackey want the same pleasures which not long ago were the monopoly of the rich alone; but the fact that all, all without exception, rich and idle as well as poor and industrious, seek and demand daily amusements, gaiety, excitement,

The lighting of Graves Light on September 1, 1905 marked a new era for Hull, as most major shipping vessels that were headed for Boston were now diverted farther away from shore.

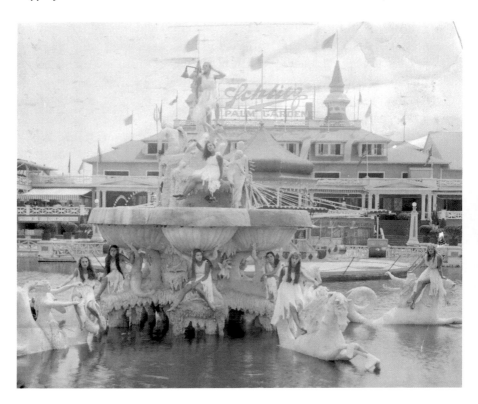

Out of the ashes of the Portland Gale rose the pageantry of Paragon Park.

A bold, brave new world

and keen impressions—demand it all as something without which life is impossible, which may not be denied them" (Morris, 663).

The *New York World* figured that if the twentieth century might possibly bring the downfall of society, it would be the first to predict the causes. Polling a wide assortment of eminent gentlemen, the editors compiled a list. Arthur Conan Doyle, the literary genius behind Sherlock Holmes, anticipated a growing tendency toward "an ill-balanced, excitable, and sensation mongering press." President Hadley of Yale feared "legislation based on the self-interest of individuals, or classes, instead of on public sentiment and public spirit." Dean Farrar declared the "dominance of drink" as our greatest potential social evil. The bishop of Gloucester decried "self-advertising vanity" (Sullivan, 372).

Much would change in Hull in just the first five years of the twentieth century. By 1905, a new channel would be dredged beyond Brewster Island and a new lighthouse erected at the Graves Ledge (known locally as "the Graves"), meaning that the venerable Lighthouse Channel, for centuries the main method of entry into the port of Boston, would no longer be as active. Joshua James, the ultimate local hero, and a rescuer of hundreds of lives, would die in the surf in his uniform after a lifeboat drill. And Paragon Park, a Hull landmark that would cast light into the night sky for the next eight decades, would rise from the earth at the southern end of the peninsula.

So, when asked what the next century would bring for the town of Hull, the average citizen probably could only shrug his or her shoulders and echo the words used by the honorable and respectable archbishop of Canterbury, when asked the same question about the world a hundred years earlier: "I have not the slightest idea."

Mischief at the Hotel Nantasket

In just a few short months, the proprietors of the Hotel Nantasket would open its doors, air out its dusty halls and call its waitstaff, bartenders, chambermaids and clerks out of hibernation. The operation of the hotel would be different this year for sure, though, as the Metropolitan Park Commission had already begun to set up shop on its newest reservation, promising to stamp out the illicit practices of pickpockets, prostitutes, shysters and illegal booze peddlers that had ruined the reputation of Nantasket Beach.

Nevertheless, as Floretta Vining of the *Hull Beacon* declared each and every year, the summer season of 1900 would be the most lucrative season ever for the businessmen and businesswomen of the South Shore.

In the cold and darkness of the early morning hours of Tuesday, February 6, 1900, however, the night watchman of the Hotel Nantasket could think of little else than keeping himself warm. To him, that lucrative summer season seemed years—or at least a long succession of chilly, lonely nights—away.

He made his rounds as usual that night, holding his lantern up to doors and windows, checking locks and assuring himself that no one had gained illegal entry into the building he had sworn to protect.

Firebugs had been at work at Nantasket for years, sometimes targeting individual cottages and other times burning down the beach's resort hotels. Many buildings were mysteriously consumed by flame during the terrible economic depression of the early 1890s, but the conflagrations did not end with the return to prosperity. Hotel owners quickly learned that they needed to keep their night watchmen on the payroll even during the quiet off-season, lest they have nothing to return to in the spring.

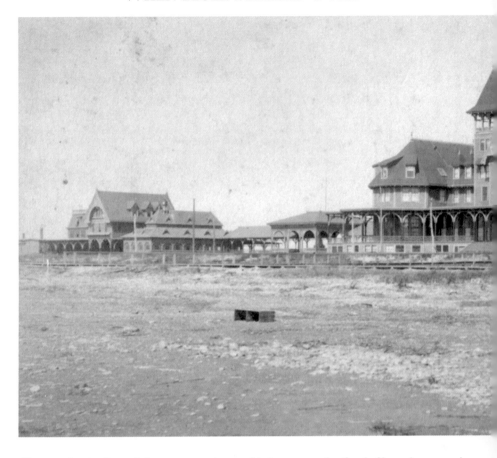

Above and right: One of the most popular establishments on the South Shore for several decades, the Hotel Nantasket was almost lost one night in February 1900.

At three o'clock that Tuesday morning, the watchman suddenly stopped in his tracks and listened. Through the night air, he could hear the unmistakable sound of turning wheels: one person, maybe two, on bicycle.

At the height of a midsummer's afternoon, such a sound would not be suspicious at Nantasket Beach, as thousands annually mounted their "boneshakers" for a tour of the peninsula. But, in the black of a February night, when the only sound heard should have been the swash of the surf, when the Nantasket playground had gone to sleep for the winter, the rattling wheels sent shivers up the watchman's spine.

The cyclists came closer and closer and then stopped, laying their glorious contraptions down alongside the hotel. The watchman, his

Mischief at the Hotel Nantasket

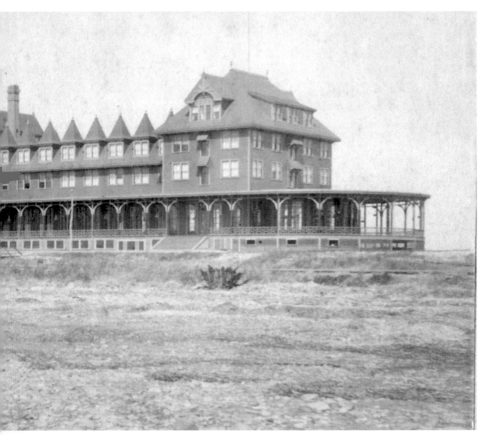

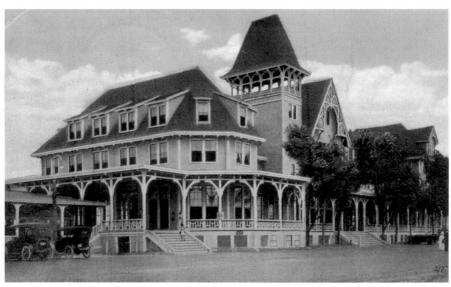

heart beginning to thump rapidly in his chest, doused his lantern and moved into position to investigate.

He watched for a while as two men, as he had suspected, crept along the exterior of the building. In an instant, though, he lost sight of them, as they somehow found a way to infiltrate the hotel's basement. Relighting his lantern and feeling his pulse quicken, he hurried to the spot where the men had disappeared. To reassure himself, he felt for his sidearm and then moved to the door.

He had barely reached the entrance when the mysterious men, realizing they had been sniffed out, charged past him and dashed for their wheels. Furiously pounding on the pedals, they disappeared into the night, kicking up a tremendous cloud of dust that obscured their retreat. The watchman never got a good look at them in the light. Knowing that he had no chance of catching them, he turned his attention instead to locating the burning torch he was convinced they had left behind.

His nose detected no smoke. He looked throughout the basement but could find no evidence of the expected mischief. Perhaps he had thwarted their plans in time. He turned to leave the basement, grabbing hold of the doorknob and sweeping his eyes across the room one last time. And there it lay, on the floor, something he had not noticed before: a simple burlap bag.

He strode over slowly to check it out; holding his lantern up high, the watchman gave the bag a kick. Instantly, he regretted the action, for out of the bag flew what he could describe only as a "carefully constructed infernal machine."

Sweat began to roll off his temples as he realized exactly what he had uncovered. A match attached to the works of a clock had been applied to a fuse, connected with about four pounds of explosives—a rudimentary bomb powerful enough to destroy the hotel and cause considerable damage to surrounding buildings.

When the clock struck at a certain time, the friction of its works would ignite the match, which would then burn down to the explosives. The resulting inferno would be seen for miles.

Why would anyone have planted such a device? Did the hotel owners have enemies? Could this be a plot devised by angry businessmen in the area who had lost their prominent positions on Nantasket's Golden Mile thanks to the encroachment of the Metropolitan Park Commission? After all, rumor had it that the commissioners would take the hotel as their headquarters. Or had simply another pyromaniac finally chosen to blow up this site?

DEARBORN & CHAPMAN'S
DETECTIVE AGENCY.

Licensed by Police Commissioners.

DETECTIVES FOR

HOTEL NANTASKET, NANTASKET BEACH,

AND FALL RIVER LINE STEAMERS.

All communications sent to

GENERAL OFFICE, 40 WATER ST., BOSTON, MASS.

Since its founding, the Hotel Nantasket had employed security forces to protect itself from those with ill intentions.

As the watchman stared in horror, the clock gave out a *tick* and advanced one minute.

Realizing that he did not know when the contraption had been set to blow, he made his decision. It may cost him his life, but he would attempt to disarm the bomb.

Placing the lantern down near enough to give him light with which to work, but far enough to keep its heat from giving the explosives any funny ideas, he sprawled out on his chest on the floor, facing the device.

After rubbing the sweat from his hands onto his sleeves, he reached carefully for the match. Slowly he pulled on it until it disconnected from the clock.

Then, as the sweat reformed on his palms, he focused on the fuse. He began to pull on it to remove it from the explosives, but it would not come free.

After drying his hands again, this time noticing they had begun shaking, he wiped his brow with a handkerchief he pulled from his jacket pocket. With his eyes as wide as they had ever been in his entire life, he again moved his hand closer to the fuse, his breathing becoming even heavier.

Again he pulled, and suddenly the fuse popped free of the explosives. He closed his eyes and blew out a long, deep breath of relief. He sat quietly for

a moment with his eyes closed until the next loud *tick* of the clock made his heart jump nearly out of his chest.

Gathering up the pieces of the "infernal machine," the watchman headed back outside to complete his rounds. When the sun rose he would inform the hotel proprietors of what had transpired in the night and would turn over to them the match, fuse, clock and explosives.

But for now, he would allow himself to spend the rest of the morning feeling that sense of pride that came with knowing that, thanks to his brave actions, one of Nantasket's most famous hotels had been spared the ignominious fate of an unexplained destruction by fire.

A leap for life

As the town's postmistress, Mrs. Worster held the responsibility of doling out two batches of mail a day from the village post office, a luxury for a small town that *Hull Beacon* publisher Floretta Vining had demanded in a face-to-face interview with the postmaster general in Washington, D.C. As the village's primary postal agent, she knew almost every face that walked through her front door. She, along with her sons, Horace, eleven, and Lawrence, eight, were among the most recognizable and respected people in town.

On the evening of March 14, 1900, the temperature dipped enough to force her to close the windows on the second floor. After kissing her sons good night and wishing them sweet dreams, she moved downstairs to stoke the embers of the fire. Satisfied they would smolder through the night, she climbed the stairs and drifted into sleep as the clock in the hall sounded ten bells.

An hour and a half later, she awoke from a sound sleep to a room filled with smoke. Alarmed, she ran to the window to air out the room and then charged in to check on her boys. She could hear coughing and wheezing coming from the inside of their room.

Rousing her sons, she began to panic. Rushing out into the hall again, she ordered the boys down the stairs, but as they began to descend the steps, flames shot up from below, chasing them all backward. With her terrified sons clinging to their bedclothes, she knew now that there could be only one means of escape.

Retreating to her room, she moved toward the window. She began tossing out whatever she could—a sealskin coat, the safe box containing the post office money and the stamps she could get her hands on—before climbing out herself. Taking a deep breath and pleading for her boys to do the same, she leapt the two stories to the ground below.

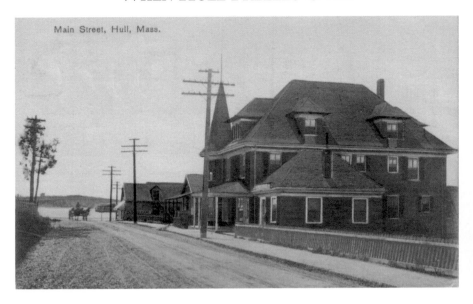

Main Street, Hull, Mass.

The small annex at the right of the building in this picture served as the Hull Village Post Office. Although the main house is gone, the old post office remains.

She slammed to earth awkwardly, landing on her back, immediately feeling a jolt to her spine. Horace followed, landing hard on his feet and badly twisting both ankles, falling to the grass with tears in his eyes and howls of pain emanating from his throat. In the confusion, neither she nor Horace saw Lawrence.

Lawrence landed on his feet and disappeared into the night, charging toward the village in his nightgown, screaming "Fire!" as mightily as his little smoke-choked lungs would allow. As the minutes passed, the building continued to burn.

Down Main Street, Walter O. Cobb heard the racket and took the boy in hand, awakening Mrs. Cobb. After calming the boy and telling him to stay with Mrs. Cobb, Mr. Cobb ran toward the Worster home.

By the time he reached the scene, Carroll A. Cleverly and William Reddie had already arrived. Together they lifted Mrs. Worster and carried her across the street to the home of Mr. and Mrs. Alfred A. Galiano. Mrs. Galiano lifted up the injured Horace tenderly and transported him to a bed. From down the street, the Hull firemen appeared, aided by two of Joshua James' lifesavers, hoping to save the building.

A leap for life

Dr. William Litchfield, aroused by the noise, came at once to the aid of the postmistress and her older boy. Because of the excruciating level of pain displayed by Mrs. Worster, the physician could only partake of a partial examination. Thankfully, he found no broken bones. Her spine, though, was badly damaged, to what particular extent he could not ascertain. Young Horace had sprained both ankles quite severely, but they would heal.

The firefighters did what they could to settle down the blaze, but their efforts would do little good. The main part of the structure, costing between five and six thousand dollars when built in 1892, was gone. All of Mrs. Worster's personal possessions, including money, furniture and several important documents, disappeared. Miraculously, the small postal annex survived. Ironically, the St. Cloud House, the home that stood on the site before, had also been destroyed by fire, eight years earlier.

Not many people slept well that night in Hull, relieved that Death had lost his grasp on the popular family but nevertheless disturbed by the close call. As the smell of the smoke lingered in the air, each resident knew how easily such a conflagration could happen to his or her home.

As long as they lived, the people of the village would never forget the Worster family and their leap for life.

Pat Crowe invades Hull Village

There once existed a time when the simple utterance of two syllables—Pat Crowe—would send the residents of Hull scrambling for shelter, bolting their doors shut tight, slamming down windows, turning out the lights and cowering in the darkness. For at one time, Crowe was America's most notorious and most wanted criminal. According to his anonymous biographer in *Spreading Evil: Pat Crowe's Autobiography*, "His teeming brain was always the radiant hub of a gigantic wheel of illusion that he could and would make crime pay" (238). From train robbing to safecracking and swindling to kidnapping, Pat Crowe did it all.

Born on a farm near Davenport, Iowa, in 1869, Crowe was one of twelve children. As a child, he was an average student, although he excelled in studying the lives of the world's great orators and statesmen. In 1881 his family moved to Crawford County, Iowa, and shortly thereafter, his mother passed away. When he turned seventeen years old, he struck out for South Omaha, Nebraska, to begin working in the meatpacking industry.

Joining forces and pooling resources with a friend, Pat Cavanaugh, Crowe opened his own butcher shop. Almost simultaneously, entrepreneurs Michael and Edward A. Cudahy and Philip D. Armour purchased a small meatpacking plant in South Omaha from Sir Thomas Lipton, of tea fame, and opened an innovative, year-round retail shop. Because of antiquated curing methods and the lack of refrigeration, meat had been sold hitherto only in wintertime. Unable to compete with the larger firm, Crowe and Cavanaugh soon accumulated three thousand dollars' worth of debt through promissory notes and were forced to sell their business. Crowe swallowed his pride and went to work for Edward Cudahy.

All went well for Crowe at first. But inevitably the day came when one of his old customers came in and begged for the butcher's help. His family

Who wanted to mess with the Hull police force of 1900?

was strong and he had no money, and he just needed a little bit of meat on credit. Crowe discussed the situation with Cudahy, who absolutely refused, citing the business rules of the house. Crowe waited until it was safe, slipped some meat to the man with a few dollars out of his own pocket and then sent him home to his family.

The next customer came in and spent twenty-five dollars. Twenty dollars reached the till. Five dollars entered Crowe's wallet. He was off on his life of crime.

For the next fourteen years, Pat Crowe led the life of a drifter. After a gun battle with police in Chicago, he ended up with a six-year prison sentence in Joliet, Illinois, for three counts of assault and one count of attempted robbery, although he was unexpectedly pardoned by the governor after a short stay.

After leaving prison, though he planned to go straight, he lost job after job once employers discovered his convict past. Finally he decided to give up trying and take his chances with crime.

He set out for the resorts of the eastern seaboard and stole diamonds with Al Adams and Mame O'Day, robbed a train in Iowa with Billy Kane and spent time in Missouri State Prison at Jefferson City with Solitary Johnson. On January 1, 1895, he broke out of jail in St. Joseph, Missouri, with

his friend Pennsylvania Slim, leaving a note for the world's most famous detective, William Pinkerton, who was coming to pump him for information: "Dear Billy, Wish you a Happy New Year, as I intend to take one myself. Will meet you at the World's Fair in Paris. Pat Crowe."

He traveled throughout the Midwest, dropping aliases in Milwaukee, St. Paul, Butte, St. Louis, Lincoln and Omaha. By his own estimation, he participated in about fifty gun battles, being wounded only once, and even that was self-inflicted (Crowe, *Pat Crowe: His Story, Confession, and Reformation*, 31).

He lived in a world replete with its own vernacular. Saloons were *gun joints*, cops were *dicks* or *bulls* and the local sheriff was the *town clown*. A potentially bountiful robbery was a *fat peter*, diamonds were *sparks*, a safe was a *jug*, loot was *swag* and trains were *rattlers*.

Sometimes the language could get completely out of control: "So Davenport and another yegg named Charlie West went out to blow a turtle somewhere, and Pat and his new pal, McKnight, heard of a then notorious octoroon named Ida Dorsey, who lived near, and who was known as 'the beautiful creole'" (*Spreading Evil*, 135).

On December 18, 1900, Crowe launched his most fiendish plot of all. After weeks of watching the home of Edward Cudahy on South Thirty-seventh in South Omaha, Crowe and compatriot Jim Callahan kidnapped the millionaire's son, Edward Jr., at gunpoint, claiming to be sheriffs from the next county.

Blindfolding the boy, the kidnappers brought him to a house on the outskirts of the city and then delivered a message to Edward Sr. They wanted twenty-five thousand dollars in gold, delivered to a certain spot at a certain time, or else they would throw acid into the boy's eyes and blind him permanently. The father, desperate, produced the money at the appointed time and site. At one in the morning on December 20, Callahan and Crowe left the boy two blocks from his home and then disappeared.

The Omaha police picked up Callahan, an unrelenting alcoholic, on a vagrancy charge after a binge paid for by brand-new twenty-dollar gold pieces.

Crowe, though, simply vanished. Cudahy put up a twenty-five-thousand-dollar reward for his arrest, adding five thousand "Dead or Alive." The Omaha City Council added twenty-five thousand to that total. Spurred on by the promise of instant wealth, private citizens formed posses and searched for America's most wanted bad man. "Thousands of men answering the description of Pat Crowe, the suspect and fugitive, were arrested in all parts

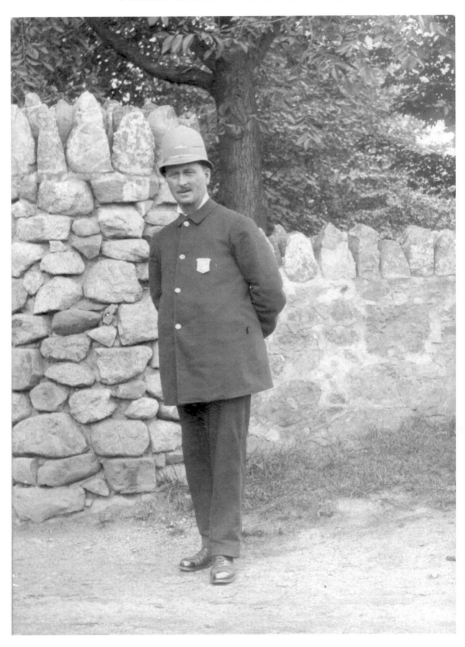

Had the notorious kidnapper Pat Crowe arrived in Hull in 1900, he would have had to deal with this burly fellow and many others.

Pat Crowe invades Hull Village

of the civilized world but the much hunted and haunted man was never found" (*Spreading Evil*, ix).

From the busiest cities to the tiniest villages, Pat Crowe sightings terrorized the American public. "The report of the appearance of Mr. Crowe in Hull acted as a curfew bell in the Nantasket metropolis. Not a youngster was seen on the streets after sundown. Even our old friend, Miss Floretta Vining, who defends Hull matters before legislative committees, looked coyly forth from behind closed blinds. David Porter Mathews roamed Broadway in Hull, notebook in hand. But Mr. Crowe did not molest him" (*Hull Beacon* 15 February 1901).

The Hull police, though, correctly refused to be taken in. "Chief John L. Mitchell received word by telephone last Tuesday night that a man answering the description of Pat Crowe, the alleged Chicago kidnapper, was on his way to Hull village. Although the senders of the message may have been honest, Mr. Mitchell concluded that the suspect was not the notorious Crowe and paid no attention to the communication" (*Hull Beacon* 18 January 1901).

Some in Hull found the whole situation to be quite comical. "Over 100 people attended the bal masque held in the town hall Thursday night, a large number appearing in costume, many of which were very elegant. Mr. J. Lester Lowe impersonating the reputed kidnapper, Pat Crowe, as a bit of fun seized young Lawrence Worcester and carried him off to the delight of the spectators and the boy's apparent dismay" (*Hull Beacon* 18 January 1901).

The kidnapper, though, never came within a hundred miles of Hull. Feeling the pressure of millions of searching eyes, he grew a thick black beard while in hiding, impersonated London newspaperman Barney Gordon and hopped a boat to South Africa, where he picked up a gun and fought against the British in the Boer War. After four months he returned to the United States and hatched a plan with Skinny McCormick and Kid Murray to kidnap John D. Rockefeller for four million dollars, but it never came to fruition. He managed to avoid capture until 1905.

In September of that year, he walked the streets of Butte, Montana, pleading with that city's police to arrest him, as he was tired of living life on the run. Taken in too many times by other "Pat Crowes," the police laughed in his face. Finally, after a week, they took him at his word and transported him to Nebraska for trial. He was received on the streets of Omaha as a conquering hero.

As the state of Nebraska had no law against kidnapping, it charged him with robbing Edward Cudahy of twenty-five thousand dollars through the kidnapping of his son. The state produced ninety-six witnesses, of whom

more than forty took the stand, and brought forth as evidence a letter from Crowe to a Father Murphy, in which the criminal stated, "I am to blame for the whole crime." Young Cudahy, now twenty, positively identified Crowe as his kidnapper.

Crowe's attorney, Albert S. Ritchie, refused to let his client take the stand, nor did he call any witnesses of his own. But on Thursday, February 15, 1906, he delivered one of the most persuasive arguments for the defense ever invoked in the state of Nebraska's history. He began with the Declaration of Independence and moved on to the Constitution and the Thirteenth Amendment; he then compared the members of the jury to Martin Luther, quoted Archimedes and juxtaposed Pat Crowe with Jesus Christ: "Maybe you think that there is a large number of people behind Mr. Cudahy and a large number of people in the community, a mob, who wants Crowe's blood...Nineteen hundred years ago there was a man who was in the hands of the mob. It was in the city of Jerusalem." (Crowe, 149).

When questioned whether or not he smoked while in the hands of his kidnappers, Cudahy looked at his father sheepishly, and then said no. Crowe threw his hands in the air in disgust, saying, "He smoked the entire time!"

The jury went into deliberation at 10:00 p.m. and returned with its verdict at 3:00 p.m. the following day: Not guilty.

The jurors, twelve common laborers (the upper classes had bought their way out of jury duty), saw the contest as being between the little man and a member of the moneyed beef trust, then on trial in Chicago on monopoly charges. Judge A.L. Sutton, disgusted with the verdict, would not allow the traditional thanking of the jury.

Crowe from there went straight. He spent the rest of his life speaking out against contract prison labor and for the need to keep young boys from a life of crime. "It is an old, well-established fact, having long since been proven so by scientific research, that is if the parents are honest their offspring, though it may wander away into sin, will eventually abandon evil and return to the good" (Crowe, 111).

Edward Cudahy Jr., apparently unfazed by the whole affair, attended Creighton University in Omaha, fought in World War I and eventually became the chairman of the board of Cudahy Packing as a well-established millionaire. In December 1919, he announced his intentions to wed and received a congratulatory telegram from Pat Crowe, the news of which doubled the nation over in laughter. Cudahy died in Phoenix, Arizona, on January 8, 1966.

Pat Crowe invades Hull Village

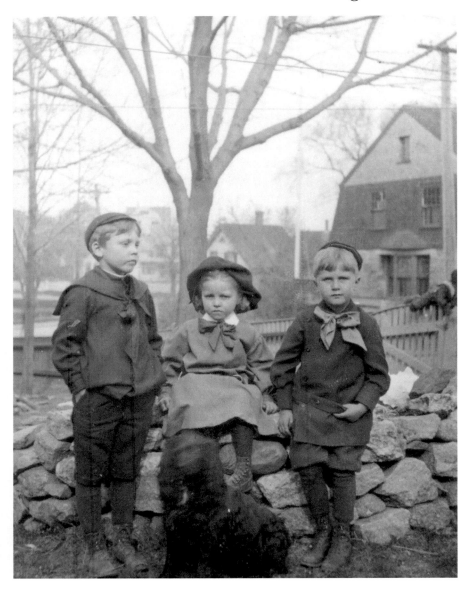

As long as the Hull police force was on duty, Hull kids need not have worried about being kidnapped by Pat Crowe.

Crowe published two biographies, one in 1906, just months after the trial, which begins with, "I want to start right by confessing in plain English that I was guilty of the kidnapping" (Crowe, 10). Then, in 1927, "white-haired and in dire poverty at fifty-six years of age," he dictated his story to a biographer who strayed well beyond the bounds of poetic license, turning Crowe into a modern-day Robin Hood.

He lived for another decade before dying destitute in New York City in 1938. In the end, his "teeming brain" had never quite been able to make the equation work. "I have taken as my part of the swag, and I am estimating it conservatively, over half a million dollars through depredations of one kind or another. Not a red cent of that money ever did me a bit of good" (*Spreading Evil*, 324). As his 1927 biography states, "Crowe's career proves, that crime does not pay."

Attacked and robbed on patrol

Every night for ten months of the year, turn-of-the-century surfmen employed by the U.S. Life-Saving Service patrolled the nation's shorelines, vigilantly watching for any sign of ships in distress. The lifesavers were on duty from August 1 to May 31, nationwide, as they were charged with guarding the shipping lanes during the stormy season, from which the summer months were excluded. Through any kind of weather, be it driving April rain, blinding January snow or muggy August heat, they covered an average of five miles per four-hour patrol. Most nights passed uneventfully; others brought surprises.

Charles Jennings, who later became the keeper of the Lovell's Island Range Lights in Boston Harbor, spent time as a young man as a surfman at Cahoon's Hollow U.S. Lifesaving Station on Cape Cod. One night, word reached the station that a local farmer's bull had escaped and was probably out on the beach.

While out on patrol that night, almost walking in a trance from the sheer monotony, Jennings caught a glimpse of some movement out of the corner of his eye, a large form careening over the dunes toward him. He ran for his life toward the water but felt a whack on the back of his legs just before he reached the surf. Terrified and confused, he dove to the ground and looked around at his attacker: a rolling, wind-driven fish barrel. He stood up, brushed himself off, looked around to see if there were any witnesses and then completed his patrol. When he returned to the station, he found out that the bull had been captured on the other side of the Cape. Then and there, he decided to never mention to any of his fellow surfmen that he had been scared out of his wits by a rolling barrel.

Surfman Clarence Smith of the Gurnet station in Plymouth went out on patrol, as usual, the night of March 23, 1894 but did not return by the

expected time. Worried about his surfman, the keeper of the station walked the patrol to find him. After the keeper had walked the entire patrol, out and back, he returned to the station to find Smith standing in the front yard, perfectly safe from harm.

When asked where he had been, Smith replied, "I will tell you the truth, I have been away with a woman, but I should not have done it if it had not been a bright moonlight [*sic*] night" (Letter from John F. Holmes, keeper of the Gurnet Life-Saving Station, to Sumner I. Kimball, general superindent of the United States Life-Saving Service, March 24, 1894). The keeper fired him on the spot.

Even the lifesavers in Hull had to expect the unexpected. Returning from patrols to Pemberton Point in January 1898, Joshua James' surfmen began to tell this tale: "Almost every night during the 'dog watch,' the lifesavers while on patrol near Battery Heights, one of the loneliest parts of the town, meet a strange woman, unknown to them, who walks beside them for a few moments without speaking, then suddenly disappears. Several of the patrolmen have met her and her strange conduct is creating considerable comment" (*Hull Beacon* January 22, 1898).

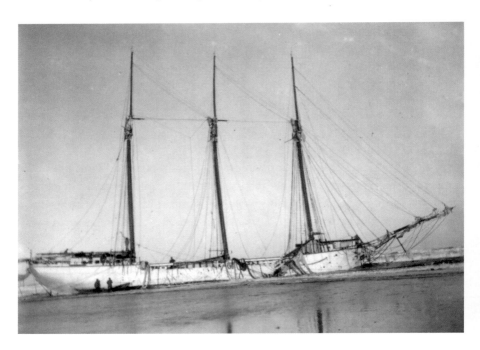

Walking the beach patrol could turn up many surprises, like the stranded schooner *Ulrica* in December 1896.

Attacked and robbed on patrol

After two weeks, the visitations stopped. Strangely, though, the spot described by the lifesavers, at the base of the sheer hill in front of the Jacobs School, is the same spot from which Melanie Lanier allegedly launched her dory the night she rowed out to save her Confederate prisoner husband, Samuel, who was being held at Fort Warren on George's Island during the Civil War. The lifesavers' encounters possibly were some of the first recorded incidents in connection with the legendary Lady in Black.

The lifesavers expected on any given night to have to battle Mother Nature; they never expected to have to wrestle with human nature. Because of the reputation that came with their uniforms, the surfmen were held in high respect by the townsfolk, for, after all, they risked their lives on a regular basis to save others. The last thing a surfman would be thinking about on patrol was being assaulted. That is, until one early March night in 1900.

On Friday night, March 1 of that year, Surfman Fernando Bearse of the Point Allerton station drew the long patrol, eastward out of the station to Point Allerton and then southward to a keypost at A Street. He had walked the patrol many times since arriving in Hull in 1897 and knew every inch of his route.

That afternoon he had withdrawn $172 from his bank account in Hingham. He and his wife, the former Helen Litchfield of Hull, had been planning to visit his family in Chatham and get away for a day or two.

The first half of his patrol passed uneventfully. He stepped into the small halfway shed that housed the keypost, punched his patrol clock and commenced building a fire to warm himself for the trip back.

When he was ready to go, he stepped out of the hut and locked it. Before he could take another step, an assailant blindsided him in the darkness, knocking him into the sand. Completely surprised, Bearse found himself wrestling for his life on the beach, but he soon managed to gain the upper hand and escape.

He ran off the beach and across the railroad tracks. But there, on the other side, two more men stood waiting for him. The first, covered in sand, joined the others in pinning the surfman to the ground, demanding that he turn over his money. Outnumbered, and fearing for his life, he acceded to their demands. The attackers then ran off into the darkness, leaving the battered lifesaver to stumble home.

When he returned to the station, covered in sand, he told Captain James his tale. He described the three men as "stalwart fellows," one of whom wore a full thick beard.

WHEN HULL FREEZES OVER

For ten years the Point Allerton lifesavers had been walking the same patrols, ten months a year, seven nights a week, up to sixteen hours a night, and not once had anyone been attacked. Yet the one night that a lifesaver happened to be carrying a large sum of money on him, about three months' salary, he was assaulted and robbed. His assailants knew where and when to find him and knew that A Street in wintertime would consist of nothing but boarded-up summer homes and complete and utter darkness and solitude. Whether they received inside information from a contact in the bank, or simply overheard that he had the money, they knew he would have it on him. This had to be a premeditated assault.

Word soon spread through the wintertime community to watch out for three strangers, one with a beard. Shopkeepers became suspicious of anybody flashing large bills (tens and twenties). None of the wealthy summer residents had arrived for the season just yet, so no one had any reason to spread that kind of wealth around.

Hull had always been proud of its lifesaving reputation. Between 1848 and 1898, townsfolk had earned dozens of medals for bravery, not even counting the deeds of the USLSS surfmen. When you spoke of Hull, you spoke of lifesaving. So when Bearse was attacked, the whole community felt the shock and closed ranks around him.

Fernando Bearse never did identify his attackers. However, four nights later, while paired up on patrol with Surfman Francis B. Mitchell, he did find a surprise. Stepping into the keypost shed at A Street on Tuesday night, Mitchell stooped to light a fire but was startled by a cry from Bearse.

It was a cry of joy.

There, on the bench, wrapped in an elastic, lay a large wad of bills. When counted, it totaled $130. It was not quite what he had started with, but it was close enough. Maybe he and his wife would get that vacation after all.

The Floretta who stole Christmas

Photographers and artists of the Gilded Age have left us innumerable images of what life was like a century ago, and perhaps the most romantic notions we hold of Victorian times come in connection with the splendor of Christmas.

The Victorians believed in extravagance and decorated every surface to the utmost of their capability. Mistletoe hung in doorways and evergreen boughs and wreaths adorned walls. In Hull, the hills afforded children ample sledding terrain, and once the village pond had frozen over, ice skates found their way out of storage and onto the feet of excited youths. There always seemed to be enough snow to ride a sleigh through the streets to visit friends and neighbors and to spread Christmas cheer. Carolers went from door to door and sang the ancient hymns, and the Hull Methodist-Episcopal Church usually presented Christmas entertainment for all.

As Hull thrived mainly as a summer resort, most of the village shops closed after Labor Day, so the townspeople looked out of town for Christmas gifts. In 1903, one could have purchased a lady's umbrella from the J.A. Price Company in Rockland for anywhere between thirty-nine cents and six dollars apiece. (Men's umbrellas cost slightly less.) Or perhaps you would have chosen some books for the children, costing anywhere from a nickel to a quarter. Adult books could go for as much as ninety-eight cents. If you wanted to stay closer to home, you could visit Joseph Breen's in Hingham. The store's ad in the *Hull Beacon* promised, "Holiday Goods in Abundance: sleds, skates, doll carriages, rocking horses—in fact everything the children want."

If you were a member of the Hull Yacht Club, you didn't have very far at all to go to shop. Need a new pair of rubber athletic shoes? Seek out member Harry E. Converse at the clubhouse, and he can direct you to his Boston Rubber Shoe Manufacturing Company. Looking for the latest

books? Charles E. Lauriat Jr.'s father is a bookseller, and he should be able to find you anything you need. How about a new bike? No problem. The bearded man in the corner is Colonel Albert Augustus Pope, a summer resident of Jerusalem Road in Cohasset, a member of the club and the man who brought the bicycle to America. He will gladly give you an address where you can purchase one of his Columbia bicycles.

Hullonians had plenty of money to spend at Christmastime in the good ol' days. On October 15, 1898, David Porter Mathews reported in the *Hull Beacon*, "the assessed valuation is almost four million dollars. No wonder there are no poor in Hull." By all accounts, a Hull Christmas in the Gilded Age should have provided merriment and joy for all.

But it did not always work out that way, for, as we know, money does not buy happiness. When we choose our personal golden ages—the eras in time we would like to go back to—we tend to romanticize what life was like. Fantasy time traveling represents a type of escapism, going back to a time when people led what we perceive to be simpler lives than our own. But, upon closer examination, we find that life did not always go as planned. Tragedies happened in the past exactly as they do today, and life still went on.

For some of Hull's citizens, Christmastime meant loneliness. From the *Hull Beacon* of December 29, 1899: "The wife of Henry Jinsberg, one of the junk dealers, was in town again Christmas Day to urge a fresh search for the body of her husband. She called at the lifesaving station, where Captain James assured her everything possible would be done to recover the body. Mrs. Jinsberg offers a reward of $50 for the finding and identification of the corpse."

Hull's most outspoken citizen, Floretta Vining, found the holiday season to be extremely hard to bear. By 1902, her mother, father and sister had all died, and as she had never married, she woke up Christmas morning completely alone, despite her vast fortune.

"Now when I tell you what I think of Christmas," she wrote in her *Beacon* editorial of December 26, 1902, "you will say, doubtless, as another has said a few days since, 'disappointed old maid, of course she doesn't like Christmas.' I tell you I hate the whole thing. Christmas, in my opinion, is for the youth, and anyone over 25 years should feel as I do. I have got to where I hate the holidays of any kind. They are sad and lonely days for broken families."

But Vining had always been a resourceful person. In the end, she knew that as alone as she was, plenty of other people had more harrowing

The Floretta who stole Christmas

Floretta Vining found the holiday season difficult by the turn of the century, as she had lost her entire family.

Alexander Vining, Floretta's father, had served the Hull community well over the years and is known as the man who got Nantasket Avenue laid out, connecting the village to the beach and beyond.

The Floretta who stole Christmas

problems to deal with at Christmastime—such as unemployment, disability and homelessness—than she ever would.

Yes, such things existed even in Hull, despite reporter Mathews' assertions. The Industrial Revolution, which had done so much for Vining's family (her father's fortune came from the sale of leather goods in Boston), ruined the lives of many others. The privileged class in the late 1800s made up about 1 percent of the population yet held 99 percent of the wealth. Conversely, the other 99 percent of the population shared 1 percent of the country's capital. Floretta Vining shared her fortune with whomever she felt needed it most.

"She has a penchant for helping needy and worthy young men, insisting always that they also strive to help themselves," wrote the editors of the *Biographical Review for Plymouth County* in 1897. "Many who are today occupying good positions owe all they are to the fact that Miss Vining tided them over the hard spot in life. In a quiet, unostentatious way Miss Vining has done this noble work, and many deeds of charity has she performed that the world knows not of. The highest reward, and the only one the lady asks, is the joy of doing service with good will."

By 1903, Vining had found a way to make her holidays more enjoyable. She realized that the spirit of Christmas lay not only in family but in community as well, and that we should make every effort to turn our community into an extended family.

In the end, we should let Vining's 1903 Christmas message, written just a year after she proclaimed she hated Christmas, speak for us all: "The lights and shadows that come to our lives live vividly at this time of year… so let us live that when the final hour comes we shall not be afraid to meet our maker. There are but slumbering embers in our hurried life, but I ask one and all to remember their neighbors and relatives this time and if any of us at Christmas giving time can add a moment's comfort our life will not be spent in vain…Give something, if ever so little to somebody and give that which they need most."

The best coot stew in town

In Hull, more so than in most places, the coming of Labor Day signifies the immediate end of summer. There may be no change whatsoever in weather conditions from one day to the next, yet Hullonians can expect thousands of visitors on Labor Day Monday, and Tuesday they can walk their own beach for miles in near solitude. Such has been the case in Hull since the evolution, in the nineteenth century, of the popular practice of the vacation.

So when the days get shorter, the leaves start to turn and the summer breezes become brisk fall winds, Hullonians find they have their town to themselves again. Traffic flows a little bit easier and life seems to simply slow down. There is no reason for outsiders to pass through Hull in the winter other than for pleasure. By geological fate, we live on a dead end.

But whereas today's residents have plenty of mobility and think nothing of getting out of town to see a movie to kill boredom in the middle of winter, Hullonians of the Gilded Age did not have such privileges. They had to find entertainment within the confines of the peninsula's watery borders or in the waters immediately surrounding it.

Some men, like Captain Harrison Mitchell, drummed up interest in sports. Others, like brothers-in-law Eben Pope and Osceola James, went deep-sea fishing or speared eels on the mudflats on the bay. Still others, like John W. and Samuel James Jr., took up anchor dragging.

Floretta Vining, the newspaper magnate of the South Shore, did her best to get a special theater train to run from Hull Village once a week into Boston. Although she enjoyed the winter in Hull, she still yearned for some big-city culture.

Each winter, more and more clubs were organized. Whist clubs met once a week, sometimes with the members dressing up in costumes just to

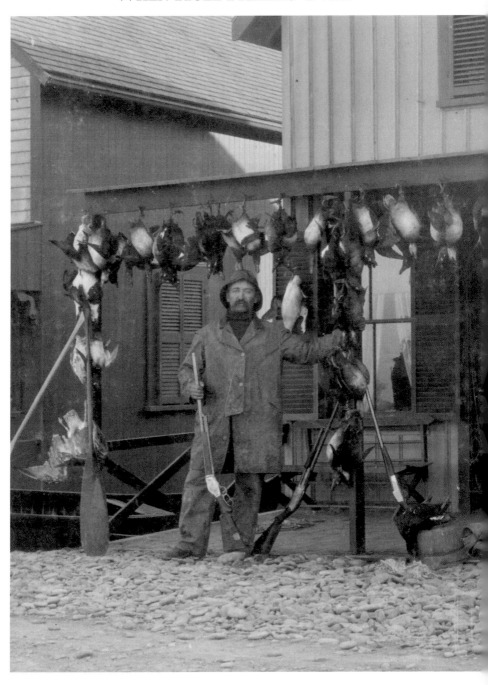

Coot gunning was big in Hull. In fact, it's how Gun Rock Beach got its name.

The best coot stew in town

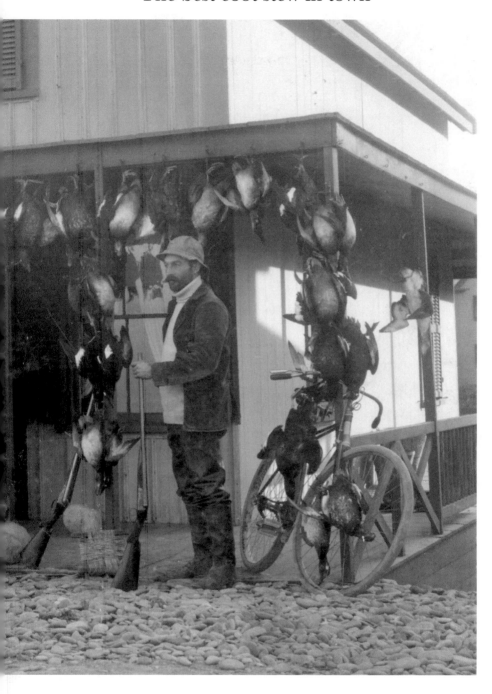

liven things up. David Porter Mathews organized the Hull Drama Club to perform plays he had written and also spent time working with the Hull Volunteer Lifesavers Band.

For the women, there was the Ladies' Sewing Circle, a tradition dating back to before the Civil War, and the James Female Orchestra. Genevieve James, one of Joshua's daughters, was a talented pianist and violinist.

Sometimes organizations popped up with inexplicable names, like the Shin-Bone Club and the Herringbone Club. In many cases, people just needed an excuse to get together.

Yet the most popular of all the late fall–early winter pastimes in Hull at the turn of the last century had to be gunning for coots. Gunners, as they were called, rowed out along Nantasket Beach before sunrise in small dories and anchored themselves in long lines perpendicular to the shore. The coots, or scoter ducks, flew in predictable aerial pathways from the north, parallel to the coast, and could be drawn in with decoys.

When flights passed overhead in loose formations, consisting of all three types of scoter (black, white-winged and surf) and possibly a few common eiders and oldsquaws, numerous guns popped at once and gunners began arguing over who got what before the birds even hit the water. A good day's hunting could net fifteen to twenty birds per person.

But there was no guarantee that a wounded bird would easily be retrieved. Scoters are excellent divers and have been known to feed at depths to forty feet below the surface. Once in the water, they will literally swim for their lives. Some birds would rather commit suicide by drowning, clinging onto firmly rooted grasses with their bills, than be caught by gunners.

Once back ashore, the gunners had the option of keeping their prizes for their families or selling them to local taverns or hotels. Advertising wars were fought through the *Hull Beacon* as hotelkeepers at such establishments as the Putnam House, the Pacific House and Taylor's Tavern vied for the distinction of having "the best coot stews in town."

Ironically, according to many recipes of the day, even the best coot stew was among the most unpalatable meals around. For example: "Take the goodly coot and nail it firmly to a hardwood board. Put the board in the sun for about a week. At the end of that time, carefully remove the coot from the board, throw away the coot and cook the board" (R.W. Hatch, *Field & Stream*, December 1924).

Other recipes say to boil a coot with potatoes and carrots for a few hours, throw in an old shoe, remove the coot and eat the shoe. Edward Howe Forbush states, "the younger birds have been found quite palatable, if

The best coot stew in town

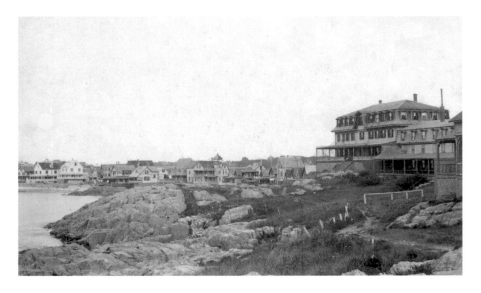

The Pacific House, the largest building on the right, was among those establishments that competed for the title of the best coot stew in town.

skinned and dressed at once" but "If allowed to hang long with the viscera unremoved, they become vile. I recall a case where a lady cooked such a bird, thereby driving everybody out of the house. She had to throw away both bird and kettle" (*Birds of Massachusetts and Other New England States*, volume 1, page 279).

The reason that coots taste so bad in a stew is that because they are bottom-feeding birds, they tend to be very oily. When they are cooked in a stew, they become saturated in those oils.

The time-honored tradition of coot hunting has all but disappeared along our shores. It just doesn't make sense to expose oneself to the biting cold of a late October morning to shoot a few birds that don't taste that good anyway. But whereas the hunters are gone, the birds remain.

According to Mass Audubon's Wayne Petersen, Point Allerton in Hull is still one of the best spots along the coast from which to watch the annual migration of scoter duck. The best time to watch their passage is during the month of October. As they fly only at night, watch for "rafts" of mixed species well offshore during the daylight hours. And hard as you might try, you probably won't find coot stew on the menu of any of Hull's restaurants today. So passes another Hull tradition into history.

Saving Old Ironsides

Napoleon had a brother named Jerome. Jerome, king of Westphalia, in an act of passion that shocked all of France, married an American, Elizabeth Patterson of Baltimore, the daughter of a prosperous merchant. Furious, Napoleon ordered the marriage annulled by the Catholic Church.

Nevertheless, Jerome and Elizabeth started a family, producing a son, Jerome Napoleon Bonaparte, who grew up to be a wealthy property owner in Baltimore. His marriage to Susan May Williams resulted in the birth of Charles Joseph Bonaparte on June 9, 1851. Young Charles would one day serve his paternal family's new country well, achieving the position of attorney general under President Theodore Roosevelt. A short stint as secretary of the navy, though, nearly ruined his career.

Backed by his parent's money, Charles Bonaparte learned from private tutors until ready to study law at Harvard, from which he received his artium baccalaureatus (bachelor of arts degree) in 1871. After being admitted to the bar in 1874, he opened his practice in his hometown, but because of his family's wealth, he had the luxury of limiting his work to his "family's properties and cases that appealed to him" (*American National Biography*, Volume 3, 154).

A "stocky little man" with a "perpetual smile," Bonaparte earned the nickname the Peacock of Park Avenue, as a "potent orator who could flay opponents" (*ANB*, 154). His passion for civil-service reform led him into political battles with Isaac Rasin, the Democratic "boss" of Baltimore, and Democratic senator Arthur Pue Gorman of Maryland. Specifically, Bonaparte spoke out against Maryland's disenfranchisement of African American citizens and for fair treatment of Catholics.

In 1881, Bonaparte played a large role in the formation of the National Civil Service Reform League. Later, while serving on the Civil Service

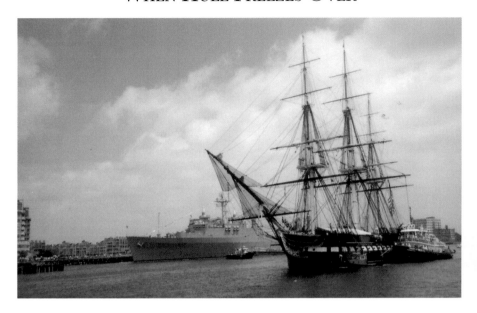

When the secretary of the navy suggested using Old Ironsides for target practice, Floretta Vining herself popped a cap. *Courtesy of John Galluzzo.*

Commission, he met and befriended another champion of the need for change in the federal appointment process, future president Theodore Roosevelt. That friendship would define the rest of his career.

Although both men believed corruption in the federal government needed to be stamped out, they sometimes sought to reach the same ends through different means.

> *Roosevelt not only propagandized for civil service reform, but he improved and revised the examinations. "Plain, commonsense questions" ought to be asked, he declared, and he thought that experience was more important than theoretical knowledge. For example, he felt that marksmanship and the ability to ride and read cattle brands were of more importance than spelling to border patrolmen in the western states. Upon learning that at Roosevelt's direction the appointees for such jobs had been chosen at a target shoot, Charles Bonaparte wryly observed that Roosevelt had been "remiss. He did not get the best men. He should have had the men shoot at each other and given the job to the survivors." (Nathan Miller,* Theodore Roosevelt: A Life, *207)*

Saving Old Ironsides

In 1901, after Roosevelt assumed the presidency of the United States upon the assassination of William McKinley, Bonaparte received an appointment to the Board of Indian Commissioners. In 1903, he led a federal investigation to probe charges of corruption in the post office. Two years later, after a reshuffling of his cabinet, Roosevelt appointed Bonaparte as secretary of the navy.

Bonaparte, of course, had no real experience for the job; however, he did not need any. Roosevelt himself had served as assistant secretary of the navy under Hingham's John Davis Long before leaving to join up with the Rough Riders for the Spanish-American War, and he essentially took on all of the work of the secretary while Bonaparte held the title. The president assigned the job to Bonaparte as the lawyer awaited the retirement of Attorney General William Moody, expected to take place in 1906. Roosevelt would then appoint Bonaparte to that position, where he could best use his talents for the American people.

So, today, we will always have to wonder who in fact penned the "Report of the Secretary of the Navy" in the *Annual Reports of the Navy Department for the Year 1905*. Did Bonaparte really write the words that brought the people of Boston to the podium to curse his name, or did Roosevelt himself ghostwrite the following report, setting up Bonaparte to accept the backlash?

> *Erroneous or greatly exaggerated reports as to the condition of the old frigate Constitution now at the Boston navy-yard led recently to some popular agitation looking to the preservation of this ship as a national relic, and also to much discussion as to the most appropriate and becoming method of perpetuating the memory of the naval victories with which her name is associated.*
>
> *In dealing with this question it is important to bear in mind that the vessel now at Charlestown is not the vessel with which Hull captured the* Guerriere. *Some portion of that ship was undoubtedly used in building the new one, to which her name was subsequently given, but probably only a very small part of these materials can now be identified with any confidence, and, in any event, it is quite certain that they constituted only a very small part of the structure of the new ship. To exhibit the* Constitution *therefore as the genuine "Old Ironsides," charging, as has been proposed, a fee for permission to inspect her, and using the amount thus earned to bear the expense of her preservation, would not only ill accord with the dignity of the Government, but would amount to obtaining money under false pretenses.*

The further suggestion that she should be rebuilt on her old lines with new materials would involve a perfectly unjustifiable waste of public money, since when completed, at a cost of certainly several hundred thousand dollars, she would be absolutely useless…I suggest that so much of the materials of the present ship as can be shown to have belonged to the original Constitution, *and to be also of some utility, or at least of no detriment, on board a modern ship of war, be transferred to a new vessel to be named the* Constitution, *and that the remainder of the ship be broken up.*

If, for purely sentimental reasons, it be thought that this supposed veteran of our old wars is entitled to a warrior's death, she might be used as a target for some of the ships in our North Atlantic fleet and sunk by their fire.

Floretta Vining had heard enough.

"My indignation towards this man knows no bounds," she wrote in her December 15, 1905 *Hull Beacon* editorial, "Secretary of U. S. Navy Bonaparte." "His career is from now on only in name, no matter how well he does his duty. I have no use for him. He has said his say and the American people rise up in their might and protest from all over the United States!" As a member of

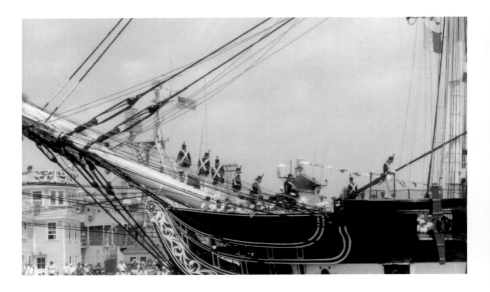

Thanks to Floretta Vining and others of her ilk, USS *Constitution* still sails today. *Courtesy of John Galluzzo.*

Saving Old Ironsides

the Massachusetts Society United States Daughters of 1812, who took on the task of raising four hundred thousand dollars for the repair of the old frigate in 1900, with the blessing of then–Secretary of the Navy John Davis Long, Vining decried the apparent void of any sense of American pride in Bonaparte:

> *Why are these patriotic societies formed all over the country by men and women, who spend both time and money to remember those that went this way for our good, who made this country what it is today? If you have no reverence in your make-up, then there is something wrong with you…It is a pretty poor man or woman that has no reverence for their own aged parents and grandparents, and this old ship is in just the same relationship to every man and woman in the United States.*

To support her cause, Vining quoted several prominent Massachusetts citizens. "Dr. Everett of Quincy, the most learned man in Massachusetts, and the son of Edward Everett, says: 'Massachusetts manned her, Massachusetts sent her away, Massachusetts welcomed her back, and if the nation is tired of her Massachusetts will buy her at any price the nation asks…Do not send her out to be destroyed by her successors on the seas, send her home to her own people who have loved her, who love her now, and who will keep her forever.'"

Governor-elect Curtis Guild Jr. echoed Dr. Everett's sentiments: "If there had been no victories won by Old Ironsides off Madeira or Brazil, if there had been no other feat of arms but this fight with the *Guerriere*, this great sea duel that marked the turning point in the sea story of the nations, that marked the United States not merely as a sea fighter but as a sea power, we should save the *Constitution* as long as plank and nail will hold together."

The Honorable William Everett, though, took a personal approach, bringing the secretary of the navy's family history into the argument. "If any official in Paris should make the suggestion that men should go to the tomb of Napoleon, take therefrom the coffin of that greatest of all warriors, place it in some square, and allow it to be shot to pieces by the French soldiery, and all this because the coffin takes up space, what would be done?"

Firing one last salvo, Vining found what she believed to be a logical counterpoint to the report's suggestion that the ship now at the navy yard was not the original. "Scientists say that the tissue of the body is renewed

every seven years; now apply the secretary's theory to himself and he is worse off than the *Constitution*, for there is not the least part of him now that existed eight years ago, he having been made over completely."

The possibility does exist that Bonaparte (or Roosevelt) intended to garner such a reaction with the report, to ignite a nationwide drive for funds to save the old vessel and take the expenses away from the federal government. Or perhaps, he (or he) meant every word written.

On July 11, 2000, wherever she was, Floretta Vining was proudly waving her American flag as she watched the *Constitution* lead the parade of tall ships taking part in SailBoston into Boston Harbor. Ninety-five years after its suggested destruction, not only was the *Constitution* still afloat, but it remained an active U.S. Navy vessel, and Vining's description of the country it serves remains appropriate today.

"Patriotic men and women abound. They are living to protect the dead, just as we shall expect our own to do for us, and with every breath we protect Old Ironsides, dear Old Ironsides."

A family's tragic past

Like many men in Hull in the early nineteenth century, Eben Pope was a hero. Born on November 28, 1848, the son of mariner William Pope and his wife, Mary (Dill), Eben grew up on the sea. In 1882, at thirty-three, he joined the ranks of Hull's volunteer lifesaving corps. During the great storm of November 25–26, 1888, he particularly distinguished himself during the rescues of the crews of the stranded *Gertrude Abbott* and *H.C. Higginson*, earning a bronze lifesaving medal and ten dollars from the Humane Society of the Commonwealth of Massachusetts, one of twenty-one Hull men to be rewarded for bravery after the storm.

Of course, Pope, a dedicated volunteer lifesaver for more than two decades, might not have had a choice but to enter the profession. On August 23, 1880, he married Joshua and Louisa James' first daughter, Louisa Julette, eleven years his junior. (Joshua and Louisa had a total of eight daughters, three of whom died of diphtheria before the age of ten, and two sons, one of whom also died of diphtheria before his second birthday.) Any man who became the son-in-law of Joshua James would most likely find himself helping out at a shipwreck scene sooner or later, one way or another.

The union had benefits that reached beyond the joys of marriage and the coming together of two of Hull's oldest families. (In fact, both Eben's mother and Joshua's mother were Dills.) In 1890, when the new Point Allerton U.S. Lifesaving Station opened on Stony Beach, Joshua James appointed his two sons-in-law as his top surfmen. Pope, married to the oldest daughter, got the number one position. Joseph T. Galiano, married to Joshua's daughter Edith Gertrude James, took the number two spot. What followed was a hierarchy established by familial ties: nephews George F. Pope and John W. James at numbers three and four,

great-nephew Francis B. Mitchell at number five, Joseph Galiano's brother Louis at number six.

In Hull at the turn of the century, winter work could be hard to come by. Without hotelgoers and other vacationers looking to sail and fish, supporting one's family while living in Hull Village could be extremely hard. A federal surfman's position came with a steady paycheck of sixty dollars per month, whether shipwrecks occurred or not. When the Life-Saving Service came to town with a small list of job openings, Joshua James made sure that his family was taken care of first and foremost.

Yet Eben Pope must not have enjoyed the daily rigors of the life of a surfman, for he stayed with the position for only three months, from the opening of the station in March 1890 to its closing for the season in May. He remained an active volunteer for fourteen more years, until 1904. In the meantime, he followed the life that his father and uncles before him had chosen, working on the sea in whatever capacity he was needed.

Pope had a good year in 1907. At least, he had a good year if we can read into the fact that the fifty-eight-year-old never appeared in the columns of the *Hull Beacon* that year, for the paper's editor, Floretta Vining, had as usual set her sights on the town's troublemakers—at least those that fit her definition—and had been liberally spreading their names through her weekly notes columns.

Vining had great hopes for 1907, even titling her May 10 editorial "1907 South Shore's Greatest Year." She based her prediction on the fact that cottage rentals were up that spring, meaning an early arrival of the social season. "As for Hull and Nantasket, most of the houses are let and this is the year that the bargain hunters are left, and I for one am glad of it. Those are the most despicable of shore visitors." The many coast artillery posts in the harbor were preparing for joint exercises to be held in early August, which obviously thrilled the Stony Beach resident to no end. "The greatest sight is to see maneuvers and the men to crawl on their hands and knees up these hills and shoot as they go" (*Hull Beacon* 2 August 1907).

However, with all that excitement to see just outside her window, Vining still had time to rail against two of society's evils, children and education.

> *Why is it that some boys seem filled with diabolical instincts, instincts to torture and tantalize everything helpless or weaker than themselves? The spirit that made Jesse Pomeroy the incarnate fiend that he was is the same spirit emphasized that possesses some boys to get a fiendish pleasure in causing pain. A few days ago a scate [sic] got stranded in shallow*

A family's tragic past

Lifesaver Eben Pope, Joshua James' son-in-law, had earned medals during the great storm of 1888, during which the *Mattie Eaton* came ashore at Nantasket Beach.

water on the bay side. In his splashing to release himself he attracted the attention of some young swimmers, and immediately the instinct of evil was aroused in them and every form of torture could suggest itself was indulged in, stoning, punching and gagging until the poor scate was torn and bleeding and then left to die. What possible "fun" could these young demons get out of such a cruel pastime and what is the rearing of such boys? (Hull Beacon *2 August 1907*)

The answer to that problem, though, was not education, as Vining saw it.

Twenty-five thousand more lawyers have been launched upon the country all expecting to be great men because they graduated from this or that college. I know families that have made themselves poor to send their sons through "Harvard." I have made up my mind this year that the youths of the day are over educated and too many take up a profession, and at the age of 35 or even thirty these young men are supported by their parents. Now this very education is going to be our ruin, because it is fast getting to a point where we cannot find a man that is willing to work at any thing but take up a profession, only to starve and still torment his family. (Hull Beacon *28 July 1907*)

That season Vining even wrote an editorial on the evils of kissing and chewing gum, and she sided heavily with the owners of beachfront property on the issue of low-water-mark trespassers, claiming that anyone collecting driftwood on the beach was stealing from beachfront homeowners.

Through all this, though, Eben Pope kept an even keel, typically staying away from Hull's hot political rumblings. As the year came to a close, he looked forward to the coming of his fifty-ninth birthday and another winter in the town he loved.

As November approached, he must have paused to think on more than one occasion about his family's tragic record for that month. On November 24, 1867, his own father, William Pope, had drowned. On November 17, 1882, the year that Eben became a lifesaver, his brother James W. Pope drowned in Boston Harbor. In fact a total of four Pope men, including an uncle and a nephew, had drowned in the month of November in his lifetime. But no fear or apprehension would strike him while crossing the waters around Hull, for he never felt more comfortable than when he was on the ocean.

On Tuesday, November 12, 1907, around six in the evening, Pope pulled into Hull's bay in a small motorboat with his brother Andrew and cousin George, both well-respected lifesavers in their prime. George towed the motorboat to its mooring. George and Andrew then headed for home, leaving Eben to secure his vessel. With the coming of winter, he would be taking his boat out of the water in about a week's time.

Later that night, around ten o'clock, Pope's wife, Louisa, called around to friends, worried by the fact that he hadn't come home. Someone told her that he had gone to his brother's house, assuming so since they had come in together. When she found that not to be the case, she frantically called out George and Andrew to find him. Calling his name all through the night, they never did. The next morning, Captain William Sparrow of the lifesaving station found him, dead on the sea floor, not too far from his mooring.

As the Pope family gathered for his funeral the next week, they could not help but think that not even Eben Tower Pope, a highly recognized and decorated lifesaver, could escape death at the hands of the sea, and they shivered knowing the now-haunting fact that he was the fifth member of his family to drown in the month of November since 1867.

Advice from an old bachelor

Marriage just is not for everyone. In fact, one self-proclaimed "Old Bachelor" not only found ways to successfully dodge matrimonial bliss but also hoped to spread the word to other confirmed single men on how to keep their solitary status during those most dangerous of times: leap years, when women are supposed to ask men to marry them instead of the traditional reversal of those roles.

He must have been quite the catch, this old bachelor, according to his thoughts on the topic of proposal avoidance, as penned in "How to Say 'No' When a Woman Proposes" in the February 7, 1908 edition of the *Hull Beacon*. "Nerve-trying Leap Year is here," he wrote, "and it behooves all unmarried men to be on the alert as to where they go and what they do and say…They—the women—may pretend to be timid and to hesitate when they propose, but the truth of it is they don't mind it a whit. In fact, they delight exceedingly in the opportunity, while the man to whom the proposal is made, if he be not possessed of extraordinary nerve power, will experience all the agony of one forced to stand barefoot on a red hot stove, or to have molten lead poured down his back."

Somehow, if we can believe his epithet, the writer must have lived through quite a few leap years unscathed, every four years watching the celebration of "a crop of marriages that man nor nature never intended, with all the resultant harvest of calamity and woe."

So how does a man do it? How does he stay single against the overwhelming odds? "Courage and firmness are the first requisites," the old bachelor stated, but he then warned the timid man that these qualities may not be enough. "Don't think at all. Just say 'no'"—Nancy Reagan would be so proud—"and then jump out of the window or by other means get away from the scene as quickly as possible and leave the town. Go somewhere

else, begin life all over again, and make it a rule to take a year's vacation every Leap Year thereafter and spend the time at some hunting resort or mining camp where no females can be found."

The man with the nerves of steel might find the following a bit easier. "No better direction can be given to this man than to employ the tactics used by women. Say, 'I will be a brother,' or 'this is so sudden,' or better still, tell the girl that you had intended proposing yourself, that you object to Leap Year proposals and ask her to wait until next year when you will have another chance to propose."

Pull no punches, he advised. "Tell her anything. Don't mind a little white lie; resort to any kind of scheme or device, but avoid the marriage."

As has always been the way in our litigious American society, men hoping to continue hanging around the local pubs after dark had to be mindful, even in 1908, of the vocabulary they chose in order to remain out of step with the wedding march. "Be very careful to word your utterances so as not to become involved in a breach of promise suit, for here is another grave danger of Leap Year. It may cost you a large sum of money, or it may cost you your life, or worse, you may be forced to marry the girl."

Of course, certain obstacles were more dangerous than others. "Under no conditions should you engage in conversation with a widow. They are threatening enough during ordinary years; their presence is absolutely fatal during Leap Year. Whenever one recognizes you on the street, merely tip your hat and pass on; never stop to speak. If she follows, dodge into a saloon and walk out through an alley into some other street…Happy is the man living in the Wild West during this dangerous period."

By way of final advice, the old bachelor stated, "Stay at home as much as possible, keep your door locked, and beware of intoxicants, for when a man overindulges he often rushes into dangers he would never dare when sober. Never think of suicide until all other expedients have been resorted to."

Many Hull men apparently read the article as youths, for by Valentine's Day, 1942, the old bachelor's advice was being well heeded. The debonair Johnny Kirraine, known as a Nantasket Casanova, that year found himself chasing a local schoolteacher. But his friends knew that when the annual bachelor hunt took place, the slick Kirraine would find a way to survive. "Despite his Barrymore manner, genial John is a wily old bird, and the chances are that he will be discreetly in seclusion at some distant point when Sadie Hawkins Day rolls around" (*Hull Times* 19 February 1942).

Advice from an old bachelor

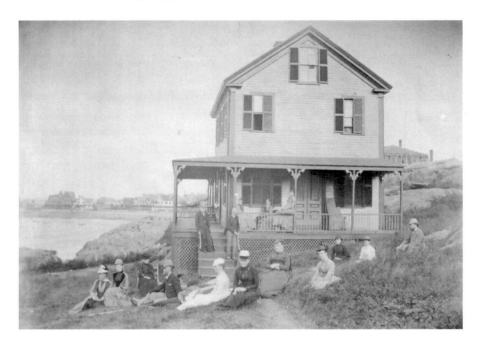

While hanging out with women at the beach could be fun, it could be dangerous in a leap year, according to at least one old bachelor.

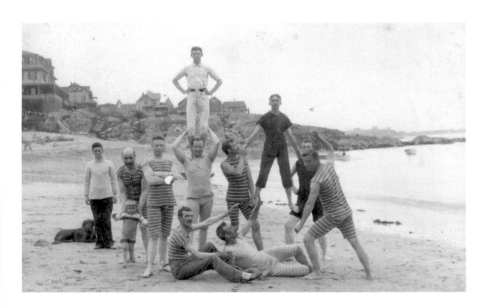

What girl wouldn't be rushing up to propose to these dandy young men at Gun Rock?

WHEN HULL FREEZES OVER

With Charley Welch as the official starter, the single women of the town lined up at Monument Square on March 15, after giving the bachelors two hours to hide. The editor of the *Hull Times*, Herb Gordon, put his money on the bachelors. Most came through unscathed, but Johnny Kirraine found the best hiding spot of all.

Two weeks after Sadie Hawkins Day, the editor received postcards written by Kirraine, from Florida. The old bachelor would have been proud.

Home for the holidays

You have to "put the paper to bed"—that is, send it to the printing press—sometime. But every editor has had one of those days when the most important story of the week broke just after the sheets were pulled back.

Floretta Vining must have inwardly laughed, if she ever laughed, while reading her own *Hull Beacon* "Hull and Nantasket" column on Friday morning, November 26, 1909: "What perfect weather for out door work," she wrote. "The numerous houses in process of erection certainly can get a good start before snow fall."

The fact was, though, that a day and a half before the release of the Thanksgiving edition of her "Oldest Paper in Hull," Floretta and others found themselves in some of the worst weather the town had seen in years.

"Not since the great storm when the *Portland* was lost has Nantasket and Hull experienced such a storm," she wrote in her December 3 editorial, "Thanksgiving Eve Storm." "While the gale increased from 12 a.m. to 72 miles an hour the New York and New Haven had a break in the South Station yard that kept every train from leaving the Depot and the train I should have left on at 5:10 did not leave until 6:20." The forty-or-so-minute run to Nantasket Junction at the Hingham line moved along well, but then the agent, James Jeffrey, held the train there until nine at night.

When Vining and company finally reached the Stony Beach crossing, "each and every one of us landed in a raging sea to walk along the highway—you got the full benefit of great waves from the Ocean washing across the street to the Bay—every one of us got a drenching never to be forgotten. One does not care to bathe in the Ocean on Nov. 24th." The railroad line beyond the Stony Beach station had been torn up, and the group had been forced to walk to the village and beyond from the intersection with Nantasket Avenue.

WHEN HULL FREEZES OVER

Both the Life-Saving Service surfmen and the volunteer lifesavers of the Humane Society of the Commonwealth of Massachusetts were out on foot, walking the beaches, wary of shipwrecks. Captain Osceola James, Joshua's son, and the Humane Society's number one man in Hull, personally carried the mail from the train to the village post office. He also watched over the passengers, who were doing their best to struggle home.

The tides scoured the beaches, causing several ruts and gullies to form. Cotton cloth from the 1904 wreck of the *Belle J. Neale* washed ashore by the bolt-load. "No houses were taken off their foundations to my knowledge as they were at Scituate about the sand hills," wrote Vining. "The sea still continues to roar and cast up large waves; it really is a great sight to see the foam from the angry waves."

Still, she did not enjoy the prospect of the sea planning an encore. "I hope we won't have another such storm this winter, but there are not the wrecks there used to be years ago, with all the signals, and Light ships and Lights and Life Saving Stations; human life is not often lost upon the ocean as it was fifty years ago."

As usual with a late fall or early winter nor'easter, the people of Hull enjoyed both good and bad aftereffects. While summer residents flocked to the shore to ascertain the damage to their cottages, those folks who had lived in town for a long time knew the sea had more to offer than the soggy bolts of cloth now hanging out to dry in backyards around the village. "The long beach was strewn with the large clams which only can be found at extreme low tide. Many a good chowder the residents of Hull have had this week" (*Hull Beacon*, December 3, 1909). The town sent an army of men out to clean up the railroad tracks and repair the line at Stony Beach.

For a while, the weather returned to its early fall splendor. The town returned its workforce to a job started the week after Labor Day, laying new water mains. John Mitchell continued construction of his new lumberyard on the block at A Street and Central Avenue, and farmers raked Nantasket Beach for the kelp that had washed ashore in large piles.

While mindful of the dangers of winter weather on December 10—"Don't be negligent about having the water shut off from your unoccupied cottage. The weather is liable to swap around freezing cold, and a burst in the pipes is apt to do a lot of damage and cause a plumber's bill of no small proportions"—Vining still couldn't help but gloat about her beloved Hull: "A lovely bouquet was picked from a garden in Hull on the third day of December. Beat that who can."

Home for the holidays

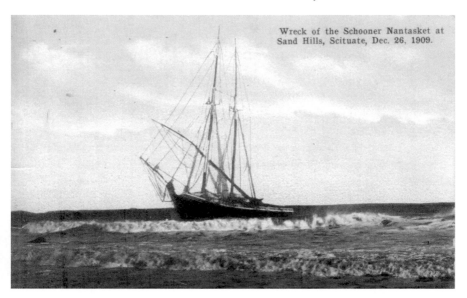

Wreck of the Schooner Nantasket at Sand Hills, Scituate, Dec. 26, 1909.

The schooner *Nantasket*, crewed by Hull men, went ashore at Scituate during the 1909 Christmas storm.

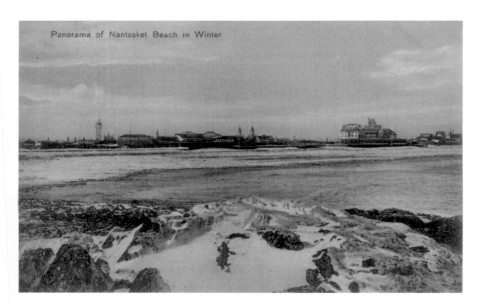

Panorama of Nantasket Beach in Winter

Floretta Vining was not expecting a scene like this in 1909.

WHEN HULL FREEZES OVER

The cold arrived the following week, as skaters headed into the Village Park for the first time, and, Vining reported, "The wind on Monday night was something to be remembered." Even so, Smith's Tavern was still reporting good business, especially among automobilists, on December 17. It was, after all, the official hotel of the International Automobile League.

On Christmas Eve, Vining, who believed with all her heart that Hull temperatures pushed the mercury ten degrees higher than at Boston all winter long, proclaimed, "The weather has been pleasant but cool at Hull and has been so for several years. One can make it here until January and February; these are the only months to go away."

December had something to say about that.

"The greatest storm ever known along the coast is the talk of every one and trying to put things in order keeps everybody busy," opened the December 31 *Hull Beacon*. "Wood by the quantities is being teamed to the homes of the residents."

"The storm on Thanksgiving eve, quite severe in its way, was not to be compared with the one that set in Christmas night," stated Vining in her editorial, "The Christmas Storm." "Saturday was a fairly pleasant day, and it was not until after sunset that there were any pronounced signs of a storm. But along during the night the storm began, and daybreak found the New England coast in the grasp of the storm king."

That Sunday morning's eleven o'clock high tide outraced even the Portland Gale's by at least five feet, according to Captain Louis G. Serovich, who had been out saving lives with the Humane Society during that fateful storm in 1898. "At Stony Beach, the tide began to come over the breakwater, across the railroad track, and poured into the low land in a torrent. People living in the vicinity were driven from their homes, and took refuge with their more fortunate neighbors."

The lifesaving station became an island unto itself as the water swirled around it. When the call for help sounded, though, the lifesavers answered. Alphonso Cleverly and family at Pemberton could not escape without the help of a boat, so the lifesavers launched and came to their aid.

The recently repaired railroad tracks at Stony Beach washed away entirely, and the station building itself was nearly destroyed. For a full three hours the braver occupants of the cottages on Stony Beach remained awash in the tide, most huddling in second-floor rooms, hoping their homes would withstand the power of the storm.

Home for the holidays

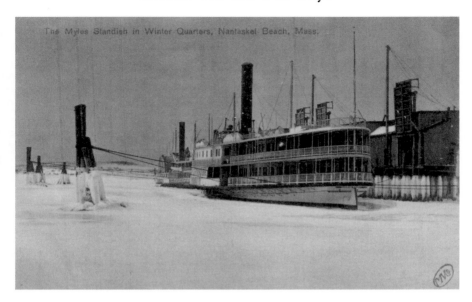

When Hull froze over, the famous Hull-to-Boston steamers went into winter quarters at the Nantasket steamboat pier.

Life in winter could be exceedingly tough on those folks without the wherewithal to afford heating. Somehow, though, Holly the Hull Hermit seemed to get by.

When Hull Freezes Over

At the east end of Hull Village, David Porter Mathews, Captain Samuel James (a seasoned but now retired storm warrior himself) and others fled from their homes as the sea rose and threatened them.

"The whole waterfront from Pemberton to Green Hill suffered severely," wrote Vining. "Great damage was done on the ocean side from Allerton to Atlantic Hill. Breakwaters were demolished, doors and windows broken in and tons of stone, gravel and driftwood deposited in the rooms and cellars."

At Green Hill, the water washed away about twenty feet of the seaside bluffs, undermining the homes standing thereon. "The houses of Charles W. Grove of Hanover and Dr. Charles R. Greeley of South Weymouth are now suspended like Mahomet's coffin, between heaven and earth."

At Gun Rock, Civil War veteran and longtime resident Horace E. Sampson and his wife barely escaped with their lives, as several houses fell from their foundations. All along the shore the flags, masts and streamers of the five-masted schooner *Davis Palmer*, lost on Graves Ledge during the storm, drifted ashore.

When the winds died, the old-timers pulled out their measuring sticks. Forget about the Portland Gale, they all said. "This storm was without exception the severest since the storm that carried away Minot's Light in 1851. Old inhabitants of Hull say that while it lasted, it was the worst they ever knew." The only redeeming trait about the storm was the fact that the wind shifted during the day from northeast to northwest, "otherwise the damage caused by the high tide of that night would have been fifty times greater."

As usual, the people of Hull got right to work rebuilding their storm-torn homes and streets. Heads were counted and handshakes and smiles greeted all the survivors of yet another winter disaster. Life went back to normal, but no one could say it had not been one heck of a holiday season.

Beginning of
the end

Hull was on the verge of something big, and Colonel Nehemiah Ripley knew it. It took some crystal-ball gazing, but it did indeed seem that the right pieces were falling into place by 1854 to make Hull a vacation resort, and therefore a moneymaking mecca for entrepreneurs willing to roll the dice.

On the surface, the town had not changed much since the American Revolution. The population of about 275 residents still lived mostly between the two hills at the far end of the peninsula, in Hull Village. Moses Binney Tower, one of those entrepreneurial types, had opened the old Robert Gould house at the corner of Main and Mt. Pleasant Streets as a boardinghouse in the late 1830s, treating guests to summer fishing excursions and all that the serenity of Hingham Bay had to offer at that time of year. But getting to the Nantasket House, as it was called, took work. No train line that ran the length of the peninsula from Hingham or Cohasset existed, and passage by carriage could be exceedingly tough, especially in the colder months. There was no County Road (now known as Nantasket Avenue) in 1854, just a beaten cart path that sometimes washed over at high tide. If you were smart, you avoided the huge sand hole near Strawberry Hill.

Henry David Thoreau had passed through Hull in 1851 on his way to Cape Cod, describing and sketching the form of Hog (now Spinnaker) Island in his journal, recognizing the *Datura stramonium*, or thorn-apple weeds, growing along the shore as a "Captain Cook among plants" and listening to the voices of Hull fishermen carrying across the water, sounding as if they were coming from just a few feet away. He also remarked in his journal about the remains of the "old French fort" atop Telegraph Hill, now nothing more than earthwork walls and empty ditches, a memory of the American struggle for independence.

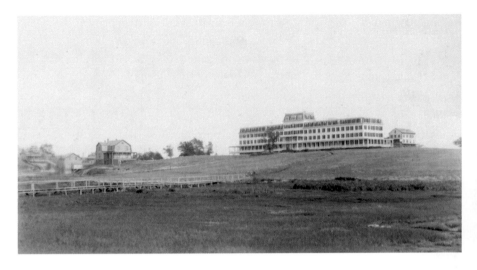

The Rockland House held a commanding view of the beach.

In the early 1840s Thoreau's fellow Concordite Ralph Waldo Emerson had spent some time at Paul B. Worrick's Sportsman, Hull's first hotel, built in 1826 near what would be known as West's Corner in years to come. But in between the Sportsman, at the south end of the peninsula, and Hull Village, where the new town hall had been erected in 1848, lay a whole lot of nothingness. A lonely telegraph wire reached from Hingham to Hull Village—still known to Hingham residents as the "moon village at the end of the earth"—suspended by poles, befriended only by sand and pounding surf.

Yet Ripley knew something that others, apparently, did not.

First, the American outlook on relaxation was changing. Firmly rooted in its agrarian past, the young United States had always been a place of dawn-to-dusk labor. If a person took leave of the family farm even for a few days, he or she had to have a damn good reason. Ultimately, only two excuses held any weight: spiritual or physical regeneration. One either headed for Hot Springs, Arkansas, or Saratoga Springs, New York, to rejuvenate the body, or for Chautauqua, New York, to refresh the soul. What's more, doctors had begun touting saltwater bathing as a health restorer in its own right. Places like Hull—with miles of saltwater coastline—became known for their salubrious properties.

Because of the gaining momentum of the Industrial Revolution, though, the notion of a six-day workweek came into vogue, especially for those men,

Beginning of the end

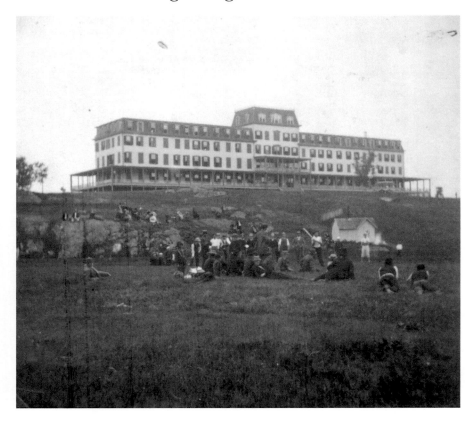

Depending on the trend at the time, the Rockland House provided baseball grounds, tennis courts and a golf course.

women and children working in factories, eventually to be shortened to five and a half and then five. What to do with the extra days? Average Americans started building porches onto homes, stringing hammocks between trees and taking daytrips to peaceful locations, just for the fun of it.

Factory owners, though, could go even farther. With extra money to spend and extra time in which to spend it, they could afford weeks or even months away from home. The notion of the vacation began to take shape during the mid-nineteenth century.

Ripley knew, too, that the South Shore Railroad Company had laid tracks through Hingham in 1849 and that steamboats had started their Hingham-Hull-Boston run way back in 1818. Even if Hull Village remained just beyond the American transportation network, the southern end of town was about to be linked to it.

Finally, reporter James Lloyd Homer had sent a series of letters to a Boston newspaper (under the pseudonym Shade of Alden), touting Hull as a burgeoning resort community in the late 1840s. People now knew the joys of frog fishing on Straits Pond, shooting porpoises in the surf and dining on boiled lobsters along the shore.

So, in 1854, Colonel Ripley opened a small, thirty-room hotel at Nantasket known as the Rockland House.

He was a man ahead of his time. Although the Civil War adversely affected the American economy in many ways, as had the ending of the post–Mexican War boom with the Panic of 1857, and as would the Panic of 1873, Ripley continued to operate and expand his hotel long before Hull's hotel era got in full swing. In 1877, the Atlantic House rose out of the rocks of Atlantic Hill, and by the 1880s, the Hotel Nantasket, Pacific House and Pemberton Hotel had arrived as well. By that time, after thirty years of running his establishment, Ripley was prepared to call it a career.

By the end of the nineteenth century, the Rockland House had claimed the title of the largest resort hotel in the United States, expanding twelvefold to approximately 360 rooms. As trends dictated, the grounds held lawn tennis courts, baseball diamonds and a golf course. New owners came and went, including famous hotel man Amos Whipple and John Sheppard of Sheppard, Norwell and Company. Manager George A. Dodge of Paragon Park added the Rockland House to that sweeping complex after the amusement park's construction in 1905, later selling it to the firm of Swithin and Merrill, the real estate magicians who turned Sagamore Hill from a barren, treeless, houseless, bald drumlin to the densely crowded neighborhood of today in one swift motion in the summer of 1906. By 1916, Patrick Bowen, once an alderman in Boston, had taken control of the old hotel.

William M. "Doc" Bergan remembered seeing the interior of the Rockland House with a friend while attending Tufts Dental School in the 1910s, as recorded on page 20 of *Old Nantasket*:

> *The place was empty on the morning that he first took me through, but I was stunned and amazed at the huge ballroom, the dazzling chandeliers, the beautiful curtains and draperies, the banquet tables and chairs around the rim of the hall, the dance area in the center and the low stage at the far end with the orchestra enclosure off to one side. He showed me two large gambling rooms with elaborate roulette wheels, the little stalls around the wheels where the players' money was kept and the rake that pushed the money around where it should go. He showed me the dice tables and how*

Beginning of the end

they operated, the poker tables with a square marked on them in front of each player where his money was kept and a circle toward the center of the table where his ante should be, black jack tables and other gambling paraphernalia that I didn't understand.

Then, on a second trip,

He introduced me to the manager, the head waiter, the boss of each gambling room, the several bartenders and then showed me what the thing actually was. The ballroom was crowded, the cabaret was in full swing. There was Harry Lauder singing a melody of Scottish songs; an English actress, Gerry Loftus, sang songs of the English music halls. One of them was, "You'd better pull down the blind." There was a lady from Ziegfield's [sic] Follies. Her name? It was fifty-odd years ago and slips my memory. She sang a catchy song, "She thought that she had lost it at the Astor," but to the audience's dismay it turned out to be a fur neckpiece.

Other acts at that time included, according to Bergan, Luisa Tetrazzini, the Florentine Nightingale; Australia's Dame Nellie Melba; George M. Cohan, who later would pen the famous World War I hymn "Over There," and Irish tenor John McCormack. President Grover Cleveland, an avid fisherman, even stayed at the Rockland House for a night or two.

By 1916 the Rockland House had been in business for sixty-three years, expanded from its original 60-foot frontage to about 320. Constructed atop a low hill with a commanding view of the Atlantic, it had stood witness to the amazing growth of the Hull peninsula. Trains had arrived in 1880, first running only between the Nantasket steamboat pier and Allerton Hill, later connected to Hingham and the Old Colony line. Electric trains had begun service in 1895. By the teens, steamboats could be counted on to carry one million passengers a year to the beach. And now automobiles could be counted on to carry thousands more. That invention would prove the ultimate downfall of both the trains and steamboats.

Hull's year-round population had begun to skyrocket with the arrival of immigrant families from Europe at the onset of the twentieth century, and the days of the 250 fisherfolk and their little moon village had come to an end. The big-money era had hit Hull, complete with a controlling, crooked political boss and his insider cronies. The state had stepped in to do its best to wrest control of the Golden Mile of Nantasket from the Old Ring in 1899 (from 1900 to 1938 the Republican Town Committee in Hull was known as

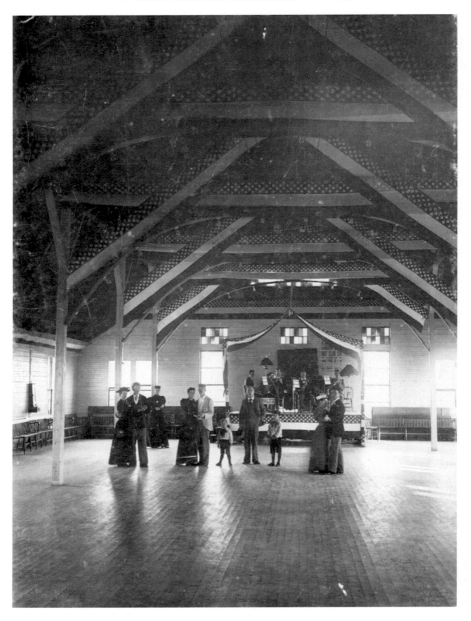

The Rockland Café was not to be confused with the Rockland House; the café was an attraction of the Hotel Nantasket.

Beginning of the end

the Old Ring) with the formation of the Metropolitan Park Commission's Nantasket Beach Reservation after the Portland Gale (which the Rockland House survived in better shape than most of its water's-edge companion hotels). Paragon Park, with its blinking lights and constant cacophony of sounds, had become one of the greatest attractions in the northeast. By 1916, Colonel Nehemiah Ripley's vision had come true.

Therefore, it must have been awful for lifelong residents of the town of Hull to watch as the Rockland House burned to the ground on February 4, 1916 during a blasting snowstorm. "The fire was visible for many miles and nearly everybody in town came to the scene," reported the *Hull Beacon* on February 11. "The going was so hard as a consequence of the recent heavy snowfall that it was with great difficulty that firemen from out of town reached the scene...The flames were fought by the combined Hull, Weymouth and Hingham fire departments until four o'clock Friday morning." With such a large structure with which to fuel itself, the fire "threatened to sweep away the entire settlement on the hill near the hotel."

According to Bergan, on page 67 of *Old Nantasket*, "A caretaker had been at the hotel all winter and used the kitchen and back part of the hotel for living quarters; that is where the fire started. No cause for the fire could be given by the firemen or the caretaker, although the 'accident' could never

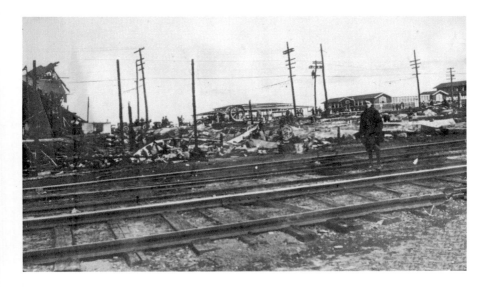

The Rockland House fire of February 1916 threatened the whole area surrounding the massive hotel.

have happened under more perfect conditions." Bergan believed that as the freedom of the automobile had allowed vacationers to choose more and more exotic vacation locales on their maps, Hull had lost its allure. He put forth the theory that the grand hotels of Hull that burned over the next decade or so did so at the hands of their owners. But, as he stated in *Old Nantasket*, no direct cause for the loss of the Rockland House could be found.

Rockland House Road today runs up and over the land that was once home to the largest resort hotel in the United States. In fact, the entire Rockaway neighborhood stands as a reminder of the days when the Rockland House was part of the Paragon Park complex, built as housing for the park's employees. Until the construction of George Washington Boulevard in the 1930s, the only means of access to the Rockaway area was through the park.

Yet, when pictures of the old hotel are shown, standing high above the surrounding beachfront, one can only imagine the opulence and splendor it once held and the high times of Hull and its great hotel era. When the Rockland House burned on February 4, 1916, on that chilly night in Hull, it marked the beginning of the end of Hull's golden years.

Just give me a chance

In 1902, writer J.W. Dalton set out to visit each of the thirteen U.S. Life-Saving Service stations on Cape Cod, from Wood End to Monomoy Point. His book *The Life Savers of Cape Cod*, published late that year, remains the most minutely detailed account of station life at the high point of the service's existence. Dalton's book not only covers the history of the service and descriptions of each station but also provides a paragraph on each and every keeper and surfman who was currently serving along the Cape's seashore. He even includes entries on the names and habits of the stations' pets. And at the end of the book, Dalton leaves space for Keeper Seth Ellis of the Monomoy station to tell his version of the lifesaving disaster of the previous March 17, of which Ellis was the only survivor.

To students of Hull history, though, the book is valuable for at least two other reasons. The more obvious reference of the two appears on page 90, under the heading "Wood End Station": "Capt. William Sparrow, now keeper of the Point Allerton Station, who was No. 1 man under Captain [Isaac G.] Fisher, acted as temporary keeper until Captain [George H.] Bickers was placed in charge." Captain Sparrow replaced Hull's legendary Joshua James just a few short months after James' dramatic death on Stony Beach on March 19, 1902. He served as keeper of the Point Allerton station into the Coast Guard years (the USLSS and the U.S. Revenue Cutter Service merged on January 28, 1915 to become the U.S. Coast Guard), retiring in 1920. He died on the Cape in 1932.

The second and more obscure reference comes earlier, on page 72, under the heading "Cahoon's Hollow Station Crew": "The No. 7 surfman is Charles H. Jennings. He was born in Provincetown in 1878, and is serving his first year as a regular surfman. Surfman Jennings was a fisherman and boatman before he entered the service, and had also substituted as a surfman

As a young man, Charles Jennings just wanted to save lives. *Courtesy of Doug Bingham and the American Lighthouse Foundation.*

at the High Head Station, under Captain [Charles P.] Kelley. He will receive careful training under Captain [Daniel] Cole, and will, no doubt, make a skilled and fearless life saver. He married Edith J. Rogers." Dalton's words proved prophetic, for Jennings would one day be commended for his bravery and skill in the saving of lives from disaster at sea. The incident would take place sixteen years later, far removed from the shores of Cape Cod, while Jennings was serving as the keeper of Boston Light.

Jennings wore the uniform of a surfman at Cahoon's Hollow station from December 14, 1902 until February 20, 1907, when he resigned to take the position as fourth assistant keeper at the twin lights of Thachers Island, off Cape Ann in Massachusetts Bay. His four years with the Life-Saving Service proved to be nearly completely uneventful, as the *Annual Reports of the United States Life-Saving Service* for the years 1902–7 list only two instances in which the crew of the Cahoon's Hollow station responded to wrecks. Both occurred in February 1903, and in both cases the stranded vessels had been abandoned by the time the lifesavers reached them. Ironically, Jennings never had a chance to save lives as a member of the Life-Saving Service.

Yet Jennings fondly remembered his time as a surfman. Self-professedly unable to "boil water without burning it," he spent his leave time learning how to cook, one of the duties he had to perform at the station. He eventually came to enjoy cooking and volunteered to become the station's permanent

cook in lieu of beach patrol. Since no one else in the station liked cooking duty, he got his wish.

Years later he would regale his family with tales of his time as a lifesaver at the turn of the century. According to his son, Harold, his stories always started the same way: "'Did I ever tell you about the time I was in the lifesaving station at Wellfleet on Cape Cod? Cahoon's Hollow?'" From there he would tell a story like the one about the night he walked the beach in fear of an attack from an escaped bull.

> *"During the day someone had gone into town for the mail. News was that a local farmer's bull had gotten loose and it was asked that the lifesaving crew walking the beach watch out for this bull...Walking that night on my watch—it was dark and only the stars were out—there was a little breeze and, listening to the surf on the beach, I was walking in a thoughtful trance. When, all of a sudden, out of the darkness, over the sand dunes, came this galloping object right straight for me. I couldn't outrun this bull, so I ran towards the surf, running as fast as I could, lantern in hand. Just as I got to the edge of the surf the bull got me—right behind the back of the legs. Down I went just like a football player tackled me. My face was within inches of the surf's waves. I got my lantern upright—it hadn't gone out. I didn't know what to do. Finally I turned around and heard this thing swishing like a top that was running down. It stopped. There beside me lay a large fish barrel. The wind had caught it just right and it had started rolling down the beach and I thought it was the bull. Of course, you couldn't go back to the station and tell anyone or you would never outlive it and maybe get a name like 'barrelhead' or 'the bull.' They finally found the bull near Mayo's beach in Wellfleet on the other side of the cape."* (Harold B. Jennings, A Lighthouse Family, 43)

In any event, Jennings left the service in 1907 to accept the position at Thachers Island with the U.S. Light House Establishment, although it meant taking a $200-per-year cut in pay. Two years later, he accepted a post as assistant keeper at Monomoy Point Light, twelve miles southeast of Chatham. In May 1916, he applied for and received an appointment as head keeper at Boston Light. The job at first paid $804 per year, although that eventually was raised to $960 annually.

Jennings arrived at Boston Light just in time for its two hundredth anniversary celebration in September 1916. He also had the distinction of being the first keeper to raise the American flag at Boston Light, on June

Jennings, on the left, poses outside Boston Light with Keepers Maurice Babcock and Lelan Hart. *Courtesy of Doug Bingham and the American Lighthouse Foundation.*

27, 1917. During the previous year's celebration, ex-president of the Boston Chamber of Commerce Charles F. Weed had noticed the absence of a flagpole at the light station and inquired as to why that was the case. When he learned that the Department of Commerce had never set aside funding for the purchase of flags and flagpoles for lighthouses, he began collecting donations for just that purpose. His efforts resulted in a fifty-five-foot pole and an American flag.

On February 3, 1918, fate finally offered Jennings a chance to become a lifesaving hero. At 3:45 a.m., the commanding officer of the Coast Guard patrol boat USS *Alacrity*, Chief Boatswain T.A. Evans, U.S. Navy, began sending distress calls by wireless that his vessel had become stranded on the rocks off Boston Light. (The reason navy personnel were manning a Coast Guard patrol boat had to do with the current world war. As per the act of January 28, 1915, signed by President Woodrow Wilson, the Coast Guard was to "operate as a part of the Navy, subject to the orders of the Secretary of the Navy, in time of war, or when the President shall so direct." On

Just give me a chance

April 6, 1917, the United States had officially declared war on Germany and its allies and entered World War I.) He also ordered six shots fired from the forward gun, more than enough to wake Keeper Jennings, who ran to awaken his two assistants, Lelan Hart and John Lyman.

Immediately upon reaching the site of the *Alacrity*'s predicament, they realized that since the ebbing tide had caused the vessel to lie over on its side, the crewmen aboard would have no chance to launch their own lifeboat. And to launch a boat from the island would be precarious at best, because of the unpredictable movements of the large ice cakes floating on the harbor. Remembering the endless hours of drilling and training he had undergone at Cahoon's Hollow with Keeper Daniel Cole, Jennings' first instinct was to fire the shot of the Massachusetts Humane Society's line-throwing gun, kept in a hut on Little Brewster Island, over the bow of the listing craft.

Evans later described Jennings' attempts in a letter to the Boston-area lighthouse inspector, dated February 13, 1918. "Mr. Jennings fired ship gun a number of times but the line parted after the shot left the muzzle of the gun the aim perfect. The shot passed directly over the ship at each discharge of the gun." After four attempts, Jennings gave up and retreated to the island to fetch the station's dory. With the help of his two assistants he "carried her across the island over the icy and slippery rocks and lowered her with safety down the sides of high and jagged rocks, launched and ran a line to the *Alacrity* amongst dangerous ice floes in danger of being crushed or capsized in the dory in true sailor fashion, taking the crew to the rocks amongst the ice floes." Risking death among the ice and surf four times over, Jennings and his assistants succeeded in bringing all twenty-four crewmen to safety.

Jennings eventually received a letter of commendation from Secretary of Commerce William C. Redfield for his meritorious service in saving the lives of the crew of the *Alacrity*.

His tradition was carried on by his only son, Harold, born in 1921. Harold grew up on Lovell's Island as the son of a "wickie," attended school in Hull and served with the navy in World War II. He moved to Eastham in 1951, where he worked as a plumber until the late 1980s. A remarkably active man late into his life, he volunteered at the Provincetown Coast Guard station, aided in the restoration of the famed Coast Guard rescue boat *CG36500* at Rock Harbor, published his memoirs in *A Lighthouse Family* in 1989 and led the drive to save Nauset Light from destruction from encroaching erosion after the Coast Guard announced the light would be decommissioned in 1993. And, according to his close friend Doug Bingham, cofounder of the American Lighthouse Foundation, he spent countless hours in Maine

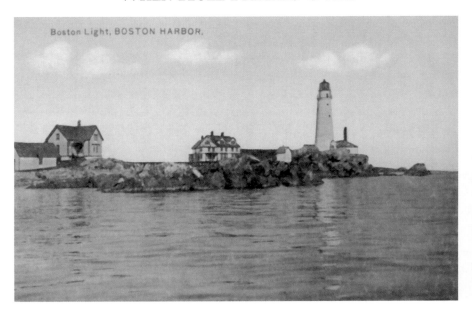

Boston Light, BOSTON HARBOR.

Charles Jennings served the boating public more than adequately at Boston Light. *Courtesy of Doug Bingham and the American Lighthouse Foundation.*

researching his family's genealogy. A descendant of Richard Stubbs, Harold Jennings never knew that his father had unwittingly moved his family to within a mile and a half of where Stubbs, progenitor of the American Stubbses, had first settled in 1642: Hull. Harold Jennings passed away in September 1996.

In 1919, Charles Jennings accepted a transfer to the Lovell's Island Range Lights, just west of Boston Light. He served there for the next two decades, until the lights were decommissioned at the end of the 1930s. He died on March 1, 1940, a lifesaving hero.

Hurricane

Considering the incredible amount of destruction the hurricane of September 21, 1938 caused throughout New England, it is amazing how comparatively lightly the town of Hull, which, as the outpost of Boston Harbor, usually bears the brunt of the region's storms, was affected. Although winds blew up to one hundred miles per hour, the peninsula gallantly withstood the storm's worst attempts to remove it from the map, even without the slightest warning to prepare.

The town had gone through a number of interesting changes during the year, changes that still impact the face of Hull today. In early February, the National Broadcasting Company ran a series of preliminary tests in the salt marshes off Nantasket Road to determine the viability of locating a WBZ radio transmitter in the area. Watching a huge dirigible rise to a height of three hundred feet above the marsh, residents joked that rather than testing for the radio station, the airship had probably either been sent to take pictures for a postcard company or to bomb the Kenberma home of John Feist and family.

The warrant for the annual town meeting, held on March 12, posed a number of out-of-the-ordinary questions to the voting populace. Article 21, voted unanimously in the affirmative, asked whether or not the town should purchase the land currently held by the trustees of the Old Colony or the New York, New Haven and Hartford Railroad Companies for the purpose of constructing a town way. Article 23, also voted in the affirmative, asked whether or not the town should earmark five hundred dollars from 1938 taxes to purchase the Old Beacon Club building at 25 Holbrook Avenue for use at the Windemere basin as a new Hull yacht club facility. The voters, though, chose to indefinitely postpone voting on Article 24, regarding whether or not to raise enough money to move the structure.

When Hull Freezes Over

The Hull police force, posed on the steps of the municipal building in 1938, was prepared for any and all action.

Other ideas brought before the town and state governing bodies that year never came to fruition. The state legislature debated a proposed Hull-to-Winthrop bridge, as it had discussed the possibility of a Hull-to-Squantum bridge six years earlier. Spurred on by their local constituents, Senator David Walsh and Congressman Charles Gifford pushed for the construction of a new Coast Guard station adjacent to Fort Revere, because the current building was entering its fiftieth year of service. Today's Coast Guard Station Point Allerton would not open until March 1970.

Rainy, stormy and foggy weather dominated the year. An early January storm resurrected the remains of Nantasket Beach's most famous wreck, the five-masted schooner *Nancy*, for one last appearance. Originally stranded in 1927, the once-proud coal-carrying vessel that had served as a tourist magnet for many years had by the mid-1930s become a dangerous derelict, inviting local children to a world of cuts, bumps and bruises. In 1937, the town succeeded in burning the hull of the boat down to the waterline, with funding from the Works Progress Administration, but could go no deeper, until now. Henry J. Stevens, commissioner of public

150

Hurricane

safety (a job created for him that combined the positions of chief of both the police department and the fire department), applied for more WPA funding that spring to finish the job.

In a heavy fog on April 22, the *City of Salisbury*, a steamer carrying, among other things, wild animals from India, struck on Graves Ledge and split in half. For weeks thereafter, visitors to Hull's shores combed the beaches in hopes of locating a box of tea, a bolt of cloth or perhaps some cashew nuts. Before the vessel sank, the animals were all removed to safety.

The heavy rain of July got so bad that a twenty-foot hole on Sagamore Hill opened up and caused a landslide that tore from the east side of Summit Road one hundred yards below to Sagamore Terrace. Trees, shrubs and two cement foundations suffered the bulk of the damage, as playing children in the area heeded the calls of adults and escaped just before the onrushing wall of mud came their way.

When the sun was out, beachgoers took advantage of it however they could. Two in particular that summer took what was deemed by the Hull police to be too much advantage and were arrested for topless sunbathing. In effecting the second arrest in August, Commissioner Stevens pointed out that "neither Kenberma street or any other section of the town should be mistaken for South Boston's L street baths at any time" (*Hull Times* 11 August 1938). Both miscreants, Abraham Gluck and Felix Gilday, grudgingly paid their assessed fines.

The schooner *Nancy*, wrecked in Hull in 1927, still sat on the beach when the hurricane of 1938 blew into town.

WHEN HULL FREEZES OVER

Two new businesses opened during the year that still remain in operation today. At West's Corner, where eighty-five-year-old shopkeeper Charles E. West still resided, West Corner Liquor Store opened its doors for the first time. And on Emerald Street in Hingham, undertaker John Pyne opened the Pyne Funeral Home.

To Hull residents, though, it seemed as if some things would never change. For the 24th consecutive summer, the rides and shows at Paragon Park thrilled thousands. For the 39th year in a row, the Citizens' Association (or Old Ring) continued its unbroken streak of endorsing winning candidates for town offices. And for the 120th season, steamboats merrily coasted back and forth from Hull to Boston.

On Tuesday, September 20, intermittent heavy rain kept most of Hull's 1,540 registered voters from the state primaries, with only 593 turning out. Those Hullonians voting on the Democratic ticket had the interesting dilemma of choosing between Governor Charles Hurley and former governor James Curley, the former a current summer resident and the latter a former summer resident. The few who stuck around until half past eleven that night learned that Hurley beat Curley by seventeen votes, while Leverett Saltonstall overwhelmingly took the Republican nomination.

That same night, forced indoors by the rain, the Hull town football team practiced under the roof of the municipal building and under the guidance of coach Jake Fleck and manager Carl O'Donnell. The team worked mostly on formations and also ran a few plays, in preparation for its upcoming game against the Neponset club on October 2.

What came next shocked all of New England. "What you have to remember first is that nobody expected anything to happen. It was not as it is now, when almost nothing, however awful, would be surprising. In those days, there was a remoteness about most things that was reassuring because it was predictable. If there was a disaster, it always occurred in one of those vague locations where they didn't wash and built their houses out of straw. There was no reason to assume that this Wednesday would be appreciably different from any other September 21" (Everett Allen, *A Wind to Shake the World*, 31).

A powerful hurricane, believed by most of the country's meteorologists to be moving harmlessly to sea, had become locked in a channel between two high-pressure systems and headed directly up the coast to strike land at Atlantic City, New Jersey, and then Long Island, New York. In twelve hours, from seven in the morning to seven at night, the 35-mile-diameter eye of the 240-mile-wide swirling atmospheric monster moved in a 600-mile line from Cape Hatteras to Massachusetts. Passing up the Connecticut River Valley,

the storm unleashed its destructive force on everything that stood in its way. Cities flooded, trains derailed and homes were smashed to bits. Hull sat on the northeastern fringe.

By four o'clock, anyone planning to see the ironic double feature at the New Loring Hall that night—*White Banner*, starring Claude Rains, and *Storm in a Teacup*, with Vivian Leigh and Rex Harrison—had to cancel his or her plans. Nervous yachtsmen raced to the Windemere basin in their cars and turned their headlights onto their craft, as the wind threatened to toss the boats to sure obliteration. One young man, David Pelham, left his car when his craft started to tear from its anchor, and in the ensuing rescue effort received a nasty blow on the knee that chipped a bone.

The wind, which reached its peak of 100 mph at 6:47 p.m. in Boston (although the anemometer at the Blue Hills Observatory registered 187 mph before it was blown away), lifted roofs off a number of Hull homes, sending them hundreds of yards from where they were supposed to be, and simply blew apart a number of beachfront piazzas. Up on Green Hill, the garage belonging to Mrs. Levi Osborne lifted straight up in the air eight feet and landed in the yard of the Trapp family down the street. At the end of the peninsula, the top half of the Pemberton Inn swimming pool ripped out and flew far down Nantasket Beach, and the house formerly occupied by the hotel's proprietor lifted off its foundation and settled directly inside the pool. Across the way, the famous Pemberton steamboat pier fell to pieces.

Valiantly, the men of the Point Allerton Coast Guard Station manned their boats and headed out to aid anyone on the sea. Surfman Joe Ottino found himself hitchhiking back from Plymouth when the storm began, coming back from leave, but reached the station in time to join Chief Boatswain's Mate Freeman Harmon, the station's new skipper, in attempting to launch the motor lifeboat. They grappled with the wind for about an hour, trying to turn their nose into the gale, but were continuously blown back against the dock. Finally, a lull allowed them to break free and join the rest of the crew out in the picket boat.

Back at the station, Surfman Francis J. LeSage, too untested to be out on a boat in such conditions, dutifully braved the weather to lower the flag at the end of the day. But it got stuck halfway down, and he had to leave it that way, confirming for some the rumors already floating through the town that Motor Machinist's Mate David Holbrook had perished aboard the picket boat. Although Holbrook did have a small rowboat sail dangerously over his head, he returned to shore safely the next day. LeSage returned to the station in time to hear the chimney on the house next door crash to the

Henry J. Stevens, the town's commissioner of public safety, died just a few days before the hurricane, leaving the town without a fire chief, police chief and chairman of the board of selectmen.

ground, a phenomenon that repeated itself all over town.

The worst of the storm moved away quickly, as it headed up toward Lake Champlain. Coast guardsmen and town employees worked through all hours of the night, lending a hand where needed, removing downed trees, restoring power and unburying vehicles. When the sun arose the next morning, all of New England assessed the damage.

Thirty-one thousand telephone poles had been broken or uprooted. Seventy-two million feet of twisted wire and four hundred miles of downed cable caused the loss of phone service to more than a quarter of a million homes. Boston could now speak to New York only via transatlantic cable to London. Twenty-six thousand cars were destroyed, as were twenty-six hundred boats. More than 275 million New England trees were ripped out of the ground for good. Approximately 750,000 chickens died during the gale. But most horrifying of all, 682 people—more deaths than in the 1871 Chicago Fire and the 1906 San Francisco earthquake combined— became defenseless victims of nature's fury.

Here in Hull, twenty boats costing an approximate total of fifty thousand dollars were destroyed or damaged beyond repair. Only one cable parted, and not a single telephone pole came down. Of the 1,714 phones in Hull, only 110 lost service. By October 4, only 9 were still down. And most important of all, not a single life was lost.

Life quickly returned to normal for the people of Hull, or at least as normal as it could be without a roof. Summer residents visited from their winter homes to check on damage, as hammers banged nails all over town. The industrious people of Hull had set themselves to their repairs immediately. As news from the surrounding areas filtered in, they knew they had been lucky to be where they were. The damage from the hurricane of '38 could have been much worse.

A shining light
in a dark world

The Japanese attack on Pearl Harbor on December 7, 1941, shocked America from its largest cities down to its smallest towns. Here in Hull, Mr. and Mrs. John D. Beal of Whitehead Avenue listened to radio news broadcasts of the assault in horror; their son Willard, a quartermaster in the U.S. Navy, had been assigned to duty aboard the USS *Oklahoma*, and preliminary reports stated that the ship had been severely damaged. In fact, it sank within the first five minutes of the attack. In Willard's last letter home to date, he had mentioned that he rarely had time to leave the ship. The Beal family prayed for a miracle. In dramatic fashion, Hull, along with the rest of the United States, entered into the Second World War.

In the coming months, Hullonians dimmed their headlights and streetlights, practiced air-raid blackouts and bade farewell to the sweeping, familiar shining ray of Boston Light, taking precautionary security measures as the town mobilized for war. The Boy Scouts collected tin, metal, rags and any other scraps the authorities called out for. Townsfolk turned in old license plates at the Central Fire Station and vinyl records to be melted down to make new ones that would be sent to America's soldiers, sailors, marines and coast guardsmen overseas.

All throughout the year of 1942, Hull families wrestled with the mixed emotions of sorrow, fear and nationalistic pride as their sons, brothers, fathers and uncles spread out across America to train to fight to defend their country. As the year wore on, letters from around the globe poured into town, telling of faraway lands and the unusual customs of their inhabitants.

Not all of the news was good, for while Willard Beal survived the attack on Pearl Harbor, the Vautrinot family of 14 Highland Avenue received word that young Donald had been wounded twice in the Philippines, the second time being struck by a bamboo bullet smeared with manure by a

Donald Vautrinot, for whom Vautrinot Avenue is named, lost his life in 1942 in a prison camp after surviving the Bataan Death March. *Courtesy of Al Vautrinot.*

Japanese soldier to deliberately cause infection. By May, the army classified Donald as missing in action. His family never heard from him again.

The first Hull boy to give his life for his country in World War II, Technical Sergeant James W. Richardson, U.S. Army, perished in an air accident over North Africa on April 19. Stricken with grief, the town nonetheless rallied behind Assessor Frank P. Richardson and family in an outpouring of community support. At an early June meeting of the Veterans of Foreign Wars, Horace Ettinger moved that the post be renamed in Jimmy's honor.

To keep up morale on the home front, President Franklin D. Roosevelt urged that all forms of entertainment continue during the war, from movies to music to sports. Although Bruins and Red Sox fans watched sadly as the famed "Kraut" line of Woody Dumart, Milt Schmidt and Bobby Bauer (renamed the Kitchener Kids for the duration) left for service on February 10, and the U.S. Navy called Ted Williams, Johnny Pesky and Dom DiMaggio to active duty shortly after the end of the baseball season, Boston fans still followed their teams closely. An occasional baseball, hockey or football game provided a three-hour diversion from the seemingly unending stream of unwanted news of death and destruction caused by the hell of war.

Although disheartened by the pervading spiritual darkness brought on by the omnipotent and menacing clouds of war, the people of Hull

A shining light in a dark world

collectively possessed enough strength of character to see beyond their own personal fears and hardships and to focus their attention on the well-being of their sons in uniform.

Realizing that because of the timing of the Pearl Harbor attack, Christmas 1941 turned out to be more or less an afterthought (not even the Flying Santa of the Lighthouses, William Wincapaw, made his usual route), the residents of Hull determined to make Christmas 1942 one holiday that their servicemen would never forget. In mid-September, commander-elect of the Oscar Smith Mitchell Post of the American Legion, Fred E. Cox, announced that the legion intended to sponsor a community Christmas fund drive to send packages to each and every one of Hull's men in uniform. Knowing that the packages would have to be mailed out by October 15 to reach servicemen overseas by Christmas, Town Clerk Andrew F. Pope, serving as the fund's treasurer, set out to raise five hundred dollars by September 30, only twenty days after the drive's kickoff.

But Hullonians had already given to the war effort in so many ways. Aside from donating their scrap material, they had been asked to temper their usage of gas and sugar. Car and bike sales had been all but frozen, open only to persons deemed by the government as critical to the war effort. With six days left, on September 24, the *Hull-Nantasket Times* reported that prospects for reaching the five-hundred-dollar goal did not look good.

The legion looked everywhere for help. On the twenty-second, each of the Hull children brought a dime to school to contribute to the fund. The town's fraternal, civic and patriotic organizations held special last-minute meetings to pass the hat. The editor of the *Times* even stooped to blackmail, warning of the dangers of not contributing: "Under no circumstances can anyone in service from Hull be one of the MEF, men everyone forgot, on Christmas. Donations may not necessarily be large, although large ones help out a lot, and any amount is gratefully accepted by the committee in charge. A complete list of all donors will be printed next week and it is an honor roll worth seeing your name on. No amounts donated will be printed and as the papers go to the boys in service the names of the 'holiday soldiers,' who never go to battle but are always on parade, as McCauley wrote, will be conspicuous by their absence." As the deadline approached, the townsfolk awaited the news.

On October 1, the *Times* ran a banner headline across the front page that read "Christmas Fund Drive Goes Over the Top"; the goal of five hundred dollars had been reached, and within a few days the fund would total more than a thousand. Ruth V. Gordon, editor of the *Times* for the duration (until

her naval reserve husband, Herb, returned from duty), printed the list of donors to thank them one and all, even an anonymous legion member who hit a three-horse parlay at the track and kept the win and show but donated the place money, more than twenty dollars, to the fund. Christmas fever struck Hull three months early.

With 225 packages to send, general fund chairman Cox set about the work of purchasing gifts. Captain Elsie Welch of the Hull Women's Motor Corps offered her ladies' services in the collection of last-known addresses of servicemen, driving out to visit the families of each soldier in town. By October 15, the committee shipped the first of the overseas packages.

For Hull's soldiers, sailors, marines and coast guardsmen, packages from home always meant a lot, but this community gift could never be topped. The committee had listened to all suggestions of items for inclusion and settled on a mix of items needed but never issued by the services and simple amenities all but inaccessible to men in uniform. Each package contained the following:

One of Hull's true heroes, Louis Anastos rescued an estimated fifty people from the Cocoanut Grove fire in 1942. *Courtesy of the Anastos Family.*

A shining light in a dark world

A fine jackknife; styptic pencils; razor blades, 15 in each box; shoe polish, black for Navy and Coast Guard and brown for Army and Marines; shoe brush; tube tooth paste; stationery, paper and envelopes in celluloid packages; tube of shaving cream; tooth brush; face cloths, two for each box; soap; plastic flashlight with two batteries; deck of playing cards; Hoyle's book of card games; pipe; cigarettes, two packages to each box; can of Cashew nuts; hard candy in cellophane pack; 2 white handkerchiefs; complete sewing kit; trench mirror; pocket game board for checkers, chess, and checkmate with all equipment; package of tobacco. (Hull Nantasket-Times, October 15, 1942)

Within a month, letters from happy servicemen began to pile up high on the desk of Fred Cox, who shared each one with the *Times*.

From John H. McCue of 297 Nantasket Avenue, with the U.S. Army: "I live in a 15 man hut and when I opened the package you should have heard the comments made by the other fellows as I took the articles out one by one. I know it would have made you feel good."

From Jimmie Rosen, with the U.S. Navy at Jacksonville, Florida: "Thanks for the swell gift, especially that book of Hoyle's card rules. It will settle a lot of arguments aboard ship."

And from Corporal Joe Regan, writing from an undisclosed location overseas: "Yesterday the Town of Hull gained 500 new admirers when I received my Christmas package from the folks back home in Hull. Everyone in my outfit who saw it said it was the best one they had ever seen."

The one letter, though, that best summed up the feelings of Hull's fighting sons came from Technical Sergeant F. Theodore Richardson, in New Caledonia off the coast of Australia. With every excuse imaginable to be bitter during the holidays, for the war had already claimed the life of his only brother, Jimmy, in April, Richardson nevertheless thanked the people of Hull for the gift and sent them this message: "The more I see of some of these distant lands, the more I begin to realize what a wonderful place America is…if I'm lucky enough to be able to come back alive I will never forget this to my dying day. Hull, at its worst, is still better than any place I've seen over here and you are all most fortunate to be able to reside in such a wonderful place."

In a world awash in darkness and hatred, the people of Hull had found a way to express love and optimism at Christmas and to make their servicemen the envy of their peers in camps all around the world.

About the Author

John Galluzzo is president of the Fort Revere Park & Preservation Society and a longtime contributor of history articles to the *Hull Times*. He has previously authored fourteen books on local and national history, including two on Hull with his friends at the Committee for the Preservation for Hull's History. *When Hull Freezes Over* is his first title with The History Press.